IMAGES
of America

HAMBURG
1910–1970

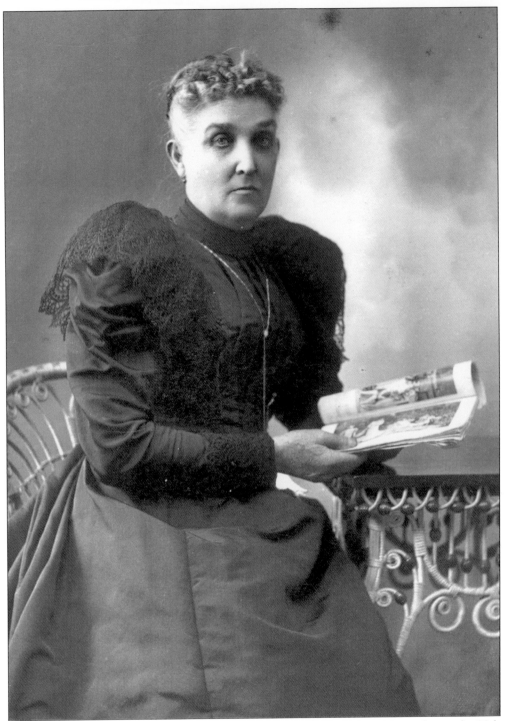

Hamburg had grown during the Victorian age, but greater changes were in store during the 20th century. This book, *Hamburg: 1910–1970*, shows many of the moments when Hamburg grew during the two world wars, developed with the coming of the automobile, and flourished by virtue of the wonderful personalities who lived there.

IMAGES
of America

HAMBURG
1910–1970

John R. Edson

ARCADIA
PUBLISHING

Published by Arcadia Publishing
Charleston, South Carolina

Printed in the United States of America

Library of Congress Catalog Card Number: 2003106973

For all general information contact Arcadia Publishing at:
Telephone 843-853-2070
Fax 843-853-0044
E-mail sales@arcadiapublishing.com
For customer service and orders:
Toll-Free 1-888-313-2665

Visit us on the Internet at www.arcadiapublishing.com

*This book is lovingly dedicated to the memory of my grandparents:
Leroy T. Edson (1891–1966) and Mae Murphy Edson (1892–1972),
Richard Joyce (1880–1939) and Blanche Dufrane Joyce (1886–1956).*

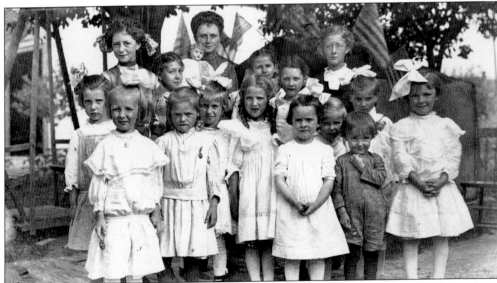

Friends of Mildred Koester have gathered for a party in her honor in June 1912. Shown from left to right are the following: (front row) Freida Bauchman, Hazel Barrett, Marie Bower, Dorothy Dietrich, Edna Anthony, Viola Miller, Mildred Koester, Beatrice Schroeder, Ida Nye, Sue Wishing, and Arline Wishing; (back row) Hazel Burman, Helen Meyer, Emma Enser, Emily Gale, and Louise Meyer. (Courtesy Hamburg Historical Society.)

CONTENTS

ACKNOWLEDGMENTS

I offer my great thanks to the Hamburg Historical Society and the Hamburg town historian and to the owners of several private collections that contain wonderful photographic material. Many individuals helped me in numerous ways as I compiled this work; I thank Joseph Streamer, James Baker, James Carlin, Jack Castle, Richard Laing, Barbara Fox, Gary Pericak, and Skip Colvin for lending me some of the photographs used in the book.

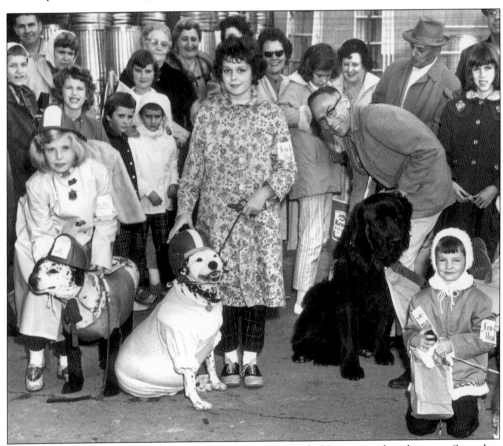

The Hamburg Shopping Center Merchants Association held a major dog show on Saturday, November 4, 1961, and attracted dogs dressed like a fireman and a football player. The shopping center ran many different activities to keep the community amused and to keep the customers shopping.

INTRODUCTION

In many ways, this book can be considered a sequel to my original book, *Hamburg*, which was published by Arcadia in 2000. While doing research for that book, I discovered what an interesting community Hamburg has always been, and I felt the story of the town was far from completed in that first work. This book covers the history of Hamburg during the years from 1910 to 1970; however, I will beg my reader's indulgence when I bend the rules a bit to include several terrific photographs that do not precisely fit this time period.

What was so great about life in Hamburg back in its heyday? George B. Abbott headed an organization known as the booster committee, which commissioned the Hamburg Publishing Company to print up a leaflet in 1917 that answered that very question. George B. Abbott later became town supervisor and eventually settled into his retirement on Marengo Street; and he certainly could sing the praises of his hometown. Back in 1917, the population of Hamburg was 3,500, and people of the time had every reason to believe that Hamburg was the ideal town for them. Hamburg's rich soil made "every spot a garden spot," and Abbott claimed the town boasted more fine gardens than any other village of its size in the United States. Numerous garden farms surrounded Hamburg, and real estate here kept increasing in value. It is said that Hamburg's canned peas, corn, and tomatoes were known the world over. Parks, glens, and tree-lined streets brought the country to the village, and the new beach and casino on the Lake Erie front offered refreshment for summer's warmest days. Unlike nearby industrial cities, Hamburg was not "clouded by furnace smoke" and the village boasted pure spring water pumped from deep wells, plentiful natural gas, and electricity from Niagara Falls for light and power. A 10-mile stretch of sewerage piping made for a healthy community, and the death rate for 1916 was 13 persons per 1,000. Hamburg was connected to the rest of civilization by five state roads and two trolley lines to Buffalo. Main and Buffalo Streets were paved in brick, and lovely residential side streets were lined with tall shade trees and beautiful, substantial homes that were occupied by their owners. Hamburg's eight flourishing fraternal orders and seven splendid churches made for a community where people could kick up their heels on Saturday night and worship on Sunday.

Abbott's leaflet boasts fact after fact, proving that Hamburg was the place to be back in 1917. "No finer high school, public or parochial schools anywhere! Finest Odd Fellow Temple in New York state . . . a new Carnegie Library and a superb motion picture theater." Hamburg's American Red Cross branch, led by George L. Pomeroy as chairman and Mrs. Charles N. Perrin as secretary, had more than 1,000 members. Hamburg's Business Men's Club had 196 members, with Charles H. Fosdick as its president. The Credit and Commercial Association had 81 members, led by druggist Frank L. Horton. Two newspapers edited by Frank Walker spread the news. News also spread quickly over Hamburg's New York Telephone Company, managed by William S. Mason; the Federal Telephone Company, managed by L.C. Kast; the Western Union Telegraph Service; and the free mail delivery, with John W. Salisbury, postmaster. Certainly, Hamburg's telephone party lines spread the local news faster and more effectively than any telegraph possibly could.

Hamburg's business community prospered in the early years. Nine new business blocks were established and 41 new homes were built in 1917. The assessed valuation of the village was $2,774,760, and its bonded indebtedness was "only $8,651—a mere trifle, compared with most villages of corresponding size." The Bank of Hamburgh, with D.C. Pierce as president and Otho Churchill as cashier, had a huge volume of business that year, totaling $13,412,421. The competition, the Peoples Bank of Hamburg, led by G.A. Drummer, president, and Henry R. Stratemeier, cashier, did a business of $8,007,734. Two savings and loans—the Hamburgh Savings and Loan Association, with Newton C. Fish as president and George J. Brendel as secretary, and the Co-Operative Savings and Loan Association, with Carlton E. Eno as president and Arthur J. Straub as secretary, "stood ready to help anyone build a home on easy payments." New streets were established within the village, and soon new homes were extending many of those roads farther away from Main and Buffalo Streets.

George Abbott said Hamburg was "fast becoming more and more the residence of business men, professional men, traveling men and employees generally, because they love to reside in such a truly patriotic and public spirited community." He asked, "Do you love a real American town, where men meet on the level for what they are worth, a town where people are distinguished for their friendly spirit and hospitality, a town whose business enterprise can be pointed to with pride, and whose business men are noted for their courtesy, honesty, and plain dealing? If you say 'yes' to any of these questions, you will find Hamburg the right place to investigate."

Anyone intent on investigating the history of Hamburg will find valuable sources. One is the *Erie County Independent*, a weekly community newspaper that recorded people, events, and ideas for Hamburg and the surrounding communities. This newspaper began in 1878 and later became the *Sun*. Microfilmed editions are available except from c. 1894 to 1923 (the high acid content of newspapers from that period may account for this deficiency). Modern issues of the *Sun* include a weekly feature called "Out of the Past," by town historians Joseph Streamer and James Baker. These articles, illustrated by historical photographs, which have been compiled in book form, are full of facts about old Hamburg and serve to keep the community interested in the town's heritage.

A committee headed by Thomas McKaig and including John Gilbert, Marjory Sipprell, William D.Allen, Mrs. George Pierce, William Kronenberg, and Ethel Thompson wrote a souvenir book from Hamburg's 1962 sesquicentennial celebration. An excellent booklet was published for the centennial of the village of Hamburg in 1974. Several historical maps and atlases show landowners, homeowners, and businesses in the village, the town, and several of the small hamlets. Thorough researchers will want to consult maps published in 1855, 1866, 1880, 1893, 1895, 1915, and 1948. An enjoyable booklet by Elton R. Heath, *Around Old Hamburg Village at the Turn of the Century*, was published in 1982 and contains a very legible map drawn by Hamburg village artist Dorothy Markert. The Sanford Insurance maps from 1885 to 1929 show just where each building stood. On-line sources such as Ancestry Plus for genealogists record the censuses for the area, reveal which houses people lived in, and list family members of a household. Cemeteries hold a wealth of information and historical clues. The collections of the Hamburg Historical Society and the Hamburg town historian both include a great deal of pictorial material and many unique photographs. Many individuals photographed Hamburg's people, buildings, gardens, and large and small events.

Hamburg has been photographed over and over by photographers who include John Van Epps, Frank L. Horton, Francis A. Uhrich, Robert Kaufman, William Kronenberg, and Everett Tooley—all of Hamburg—and William W. Potter and Isaac Kingsland of Blasdell. Van Epps's Drugstore, in the Bunting Block, on the corner of Main and Buffalo Streets, carried Kodak products and produced postcards with Hamburg views in the form of real-photo postcards and German printed hand-colored cards. The yearbooks from the Hamburg Academy and High School are informative and contain several photographs of businesses in the advertisements.

Certainly, a written history may be subjective, flawed, and incomplete; however, this effort is offered with high hopes of encouraging affection for home, community, and the past.

One

HAMBURG'S
SESQUICENTENNIAL
CELEBRATION

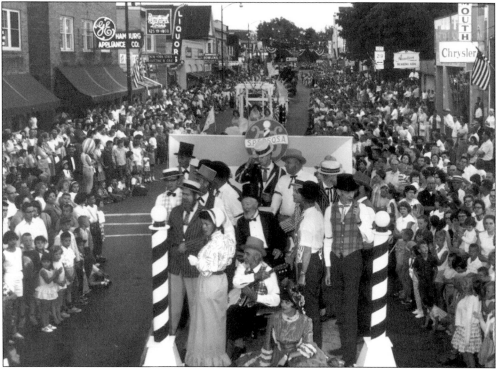

The town of Hamburg was known for its huge parades. Two of the greatest parades ever were held during the sesquicentennial celebration of June 1962, marking the 150th anniversary of the town's 1812 founding. This gigantic parade included 80 floats and attracted thousands of visitors. This view looks down Buffalo Street from Union Street. (Courtesy Hamburg Historical Society.)

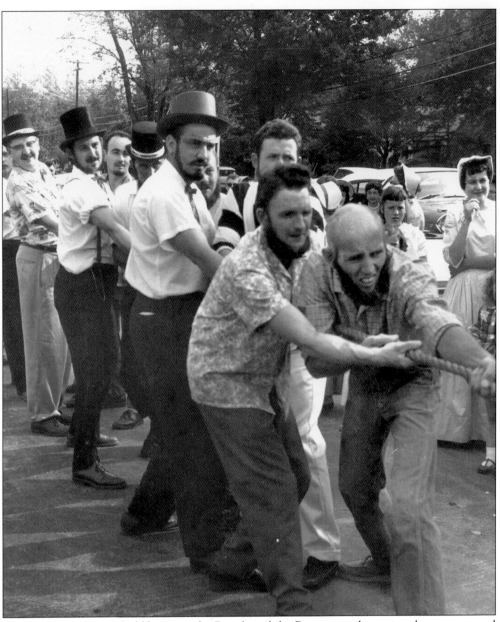

A great tug-of-war was held between the Beards and the Bonnets to determine the stronger and weaker sex in Hamburg. Hamburg men wore top hats, sesquicentennial bow ties, and sported

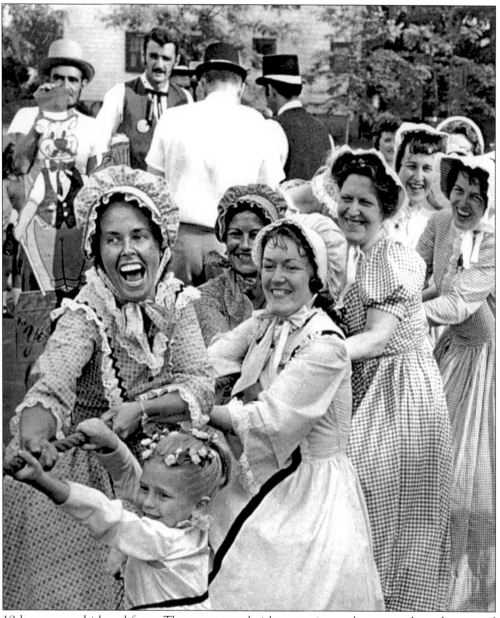

19th-century whiskered faces. The women and girls wore pioneer homespun long dresses and black bonnets. The tug-of-war contest was judged by Edward Snashell.

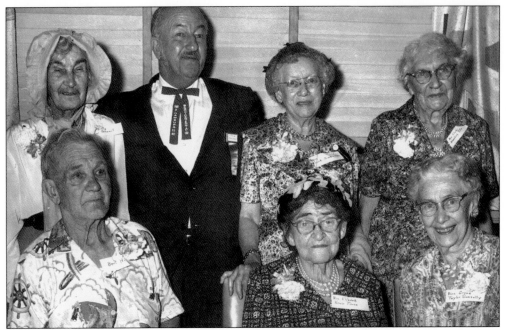

The pioneer dinner, held at the Hamburg Hotel on June 29, 1962, honored native-born Hamburg residents 75 years of age and older. A total of 100 seniors attended and received boutonnieres and golden half-dollar pieces. Six of the 12 oldest are shown with Elton Heath (back row), Hamburg Historical Society president. From left to right are the following: (front row) Bert Hines, 85; Elizabeth Kruse Pierce, 88, and Grace Taylor Gunsolly, 83; (back row) Mary Vogel Schwert, 83; Rose Scheidle Armbruster, 82; and Clara Wheelock Titus, 87. Also honored were Jenny Kruse, 91; Louise Stratemeier Knapp, 86; Ludwig Faulhauber, 86; Sarah Newton Printy, 85; Charles Haushalter, 82; and Anna Knaack Tillner, 82. George Platt, 81, gave the blessing at the dinner.

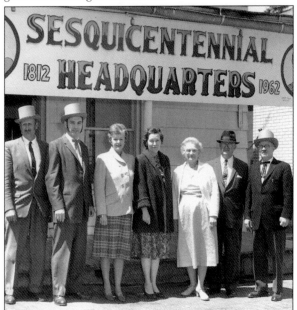

The organizing force behind Hamburg's sesquicentennial poses in front of headquarters—the old Neussle, or Weber's Hotel, on Buffalo Street. Shortly after the celebration, the hotel was razed. Shown, from left to right, are Lester Burgwardt, Fred E. Leyda, Mrs. George Pierce, Mrs. Sherwood Sipprell, Esther M. Leyda, Walter Connell, and George Sipprell. George Sipprell, general chairman of the event, said it "surpassed our wildest expectations." From 1951 to 1986, Sipprell was treasurer of the Erie County Fair, which he was credited with getting out of debt. He was the first president of the Hamburg Historical Society and was Erie County budget director in 1961. He died on February 15, 1994.

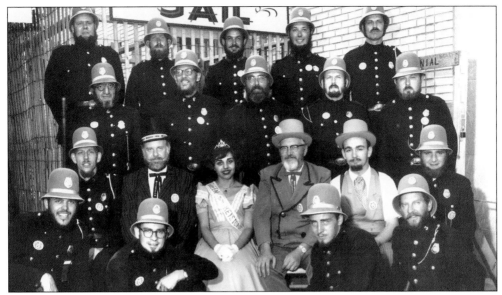

The Keystone Kops was one of the new fraternal organizations created for the week-long sesquicentennial by the Bearded Brotherhood. Geraldine Patti was crowned queen of the Keystone Kops; Nancy L. Reeder was named Miss Hamburg Sesqui; her court included Margaret Cochran, Nancy Gaughan, Joan Wheeler, and Sherrie Hancock. The nearby town of Eden celebrated its own sesquicentennial one week after, crowning 92-year-old Mrs. Louis Keehn of Hemlock Road as its queen.

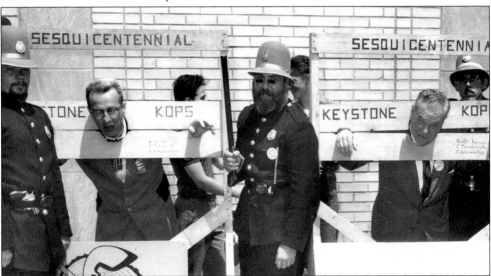

The Keystone Kops put men in the pillory for breaking the law that required all men to wear beards for Hamburg's anniversary celebration, among them Charles J. Gaughan, Hamburg town supervisor, and Edward Rath, Erie County executive. Morgan Goodwin served as judge of the kangaroo court. The festivities ended Saturday at midnight, but a crowd of 200 at the corner of Main and Buffalo Streets did not disperse. Some actual problems occurred after 1:30 a.m., when "the usual troublemakers" (unruly youths) stopped motorists, launched bottles in the air, and rocked a bus. Lt. Roland Stuhlmiller sprayed water on the youths, 11 of whom were taken to town court and reproached for their "open defiance of law enforcement officials."

13

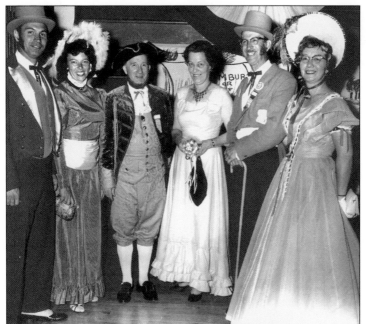

The sesquicentennial ball was held in the gymnasium of Hamburg High School on Friday, June 29, 1962, at 9:30 p.m. The gala costume ball featured old-fashioned music and a grand march at midnight. Tickets cost $3 per couple or $1.50 for a single. Shown from left to right are Mr. and Mrs. Robert Muller, Sherwood and Marjory Sipprell, and Mr. and Mrs. Lester Burgwardt.

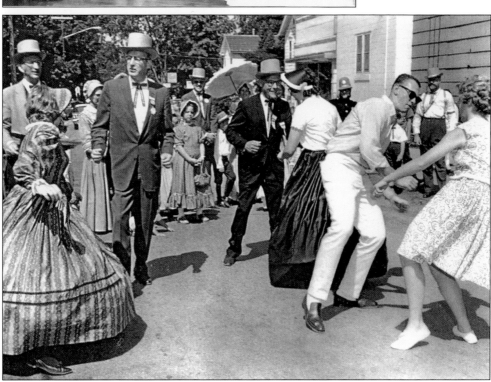

Chubby Checker invented the Twist in 1959, but at Hamburg's sesquicentennial street dance, people proved that the Twist could be done while wearing hoop skirts and top hats, as well as in snug chinos and sunglasses. George Sipprell (right of center) served as general chairman of the festivities. Sipprell claimed the sesquicentennial week was the greatest week in Hamburg's 150-year history.

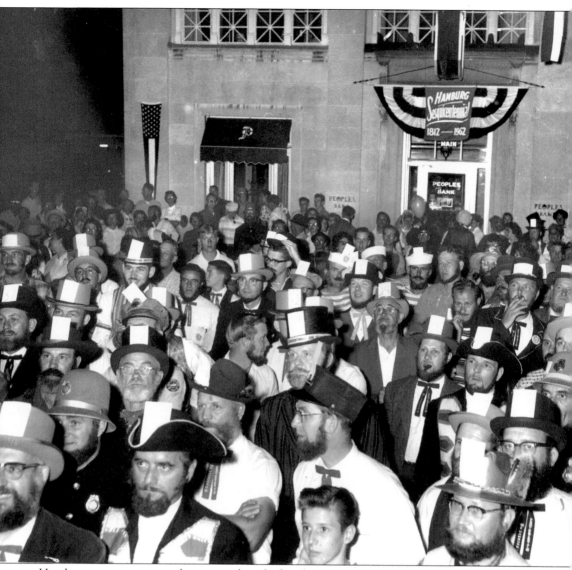

Hamburg men were urged to grow beards for the 1962 sesquicentennial celebration. On February 28, some 150 bearded brothers met at Hamburg Town Hall to form new fraternal organizations such as the Keystone Kops. Charter members wore top hats and sesquicentennial ties and buttons, and they vowed not to shave for the next four months. On Saturday, June 30, they met on the Sesqui Mall to shave. The committee provided shaving water, but no razors or shaving equipment. No electric razors were permitted either. Prizes were given for the most accomplished in these categories: best all-around beard, longest beard; fanciest beard, curliest beard, goatee, muttonchops, Van Dyke, Abe Lincoln, Robert E. Lee, halo, moustache, and burnsides. Fred W. Longbine of Camp Road won the shave-off event by removing his thick red beard in 3 minutes and 38 seconds. The Sesqui Mall was a section of Main Street between Buffalo Street and the Peoples Bank that was closed to traffic during evening events that were held on the street.

The sesquicentennial Veterans Day celebration was held on Thursday, June 28 at the Soldiers Monument in the village park. Reveille ceremonies were conducted at 8:00 a.m. by Hamburg Veterans organizations, including those in historic costumes. At 5:00 p.m., retreat ceremonies were held and an aerial salute was fired in honor of Hamburg's war dead. At 7:00 p.m., a huge Veterans Day parade began at the Junior High School athletic field, on Pleasant Avenue. Wanda Wheeler Daetsch of Pierce Avenue sewed a special 15-star American flag that was raised in front of the celebration headquarters.

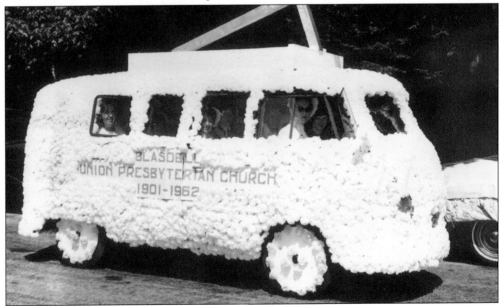

The Civic Day parade featured floats of every description. The Blasdell Union Presbyterian Church on Lake Avenue entered this Volkswagen bus covered in Kleenex pom-poms, surmounted by a cross, and driven by Joseph Streamer. New York Telephone Company employees built a very elaborate float called "the Old Mill," with an actual log cabin and a waterwheel that moved by waterpower. The 80-unit parade, which attracted a crowd of 25,000 spectators, included 24 horse-drawn vehicles from Jamestown.

Two

Hamburg Grows
in Every Direction

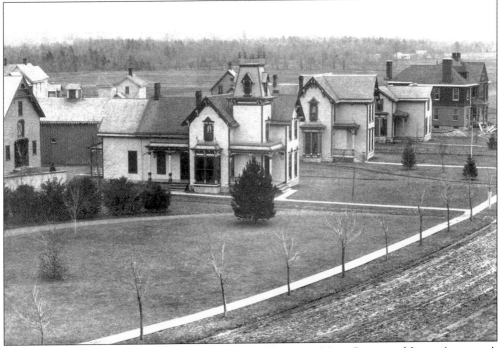

These fine homes were built along Pierce Avenue between Main Street and Long Avenue. A 1909 map of the village shows that the lots belonged to Bunting, J. Stein, G. Bunting, and D.C. Pierce. At that time, Pierce Avenue had wooden sidewalks and a line of sapling trees. These houses were demolished to make room for the Pierce Square Apartments. (Courtesy Hamburg Historical Society.)

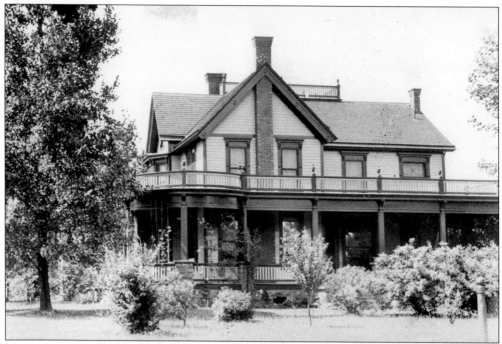

George M. Pierce built this beautiful home at 201 Pierce Avenue for his daughter. It has a stone foundation, a veranda, and glittering cut-class windows. Also known as the Martin House, it was owned by Almon D. Baker during the 1970s.

The gracious home of Dr. F. Granville and Ada L. Barnes was built at 170 Main Street and photographed on August 26, 1908. Niece Eleanor Greenfield also lived here. The Greek Revival front porch, with its four columns, protects a lovely stained-glass window on the first floor. Servants and deliverymen used the side entrance. The horse barn stands to the rear of the property. Today, this address has become 242 Main Street and the stable has been converted to apartments.

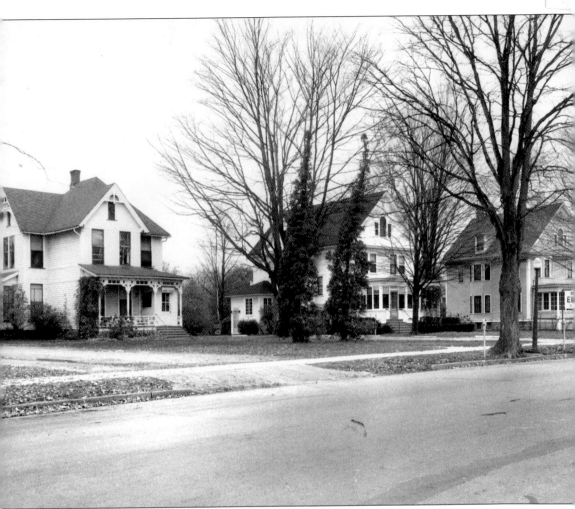

These three large family homes once lined Buffalo Street between Union and Pleasant Avenue. From left to right are the home of Charles and Bertha Fletcher, at 90 Buffalo Street, which was demolished to make a parking lot for the Masonic temple; the home of George and Amelia Hickman, which became the Benevolent and Protective Order of Elks clubhouse before it was demolished for the building of the Rosewood Seniors Home; and the home of insurance man Jacob Hauck, his wife Clara, and son Fred, which was moved to Huron Street when the lot was purchased for the new location of the Hamburg Public Library. (Courtesy Hamburg Historical Society.)

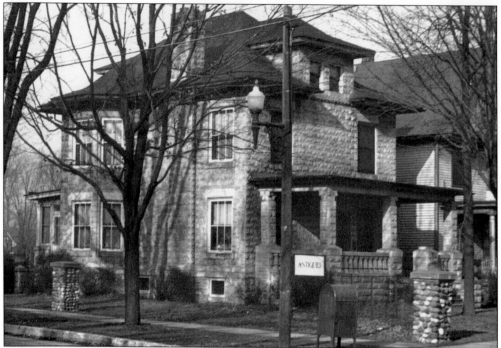

Some of the houses on Prospect and Hawkins Avenues and Buffalo Street are constructed of cement blocks. This home at 70 Hawkins Avenue was built *c.* 1906 by Andrew Haberer, who came from Dunkirk to work as a cement contractor in Hamburg. It took two years to build the house; Haberer made the block forms himself and used gravel from the Zittel farm. (Courtesy Hamburg Historical Society.)

Two cement-block houses, 160 and 166 Prospect Avenue, were built across the street from the clay tennis courts on the corner of Hawkins and Prospect Avenues, where the Hamburg Glen is located today. These small houses originally cost about $2,000 to build. They were comfortably cool in summer but damp inside and difficult to heat during the cold weather. Hamburg businessman William Conrad and his brother, John Conrad, had a cement-block factory located between East Prospect Avenue and Elizabeth Street near Buffalo Street in the 1920s, and they also made blocks for Hamburg's cement-block buildings. (Courtesy Hamburg Historical Society.)

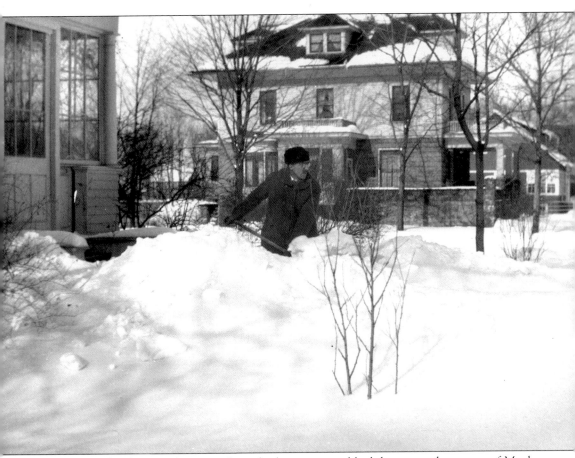

Arnie Titus lived across the street from the large cement-block house on the corner of Maple Avenue and Division Street. He was an officer at the Hamburg Savings and Loan Company and a good friend to anyone needing a mortgage. He did not believe in all the forms and red tape of a mortgage application; one's word was good enough for him. (Courtesy Hamburg Historical Society.)

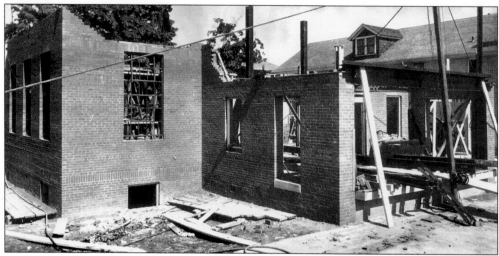

When built in 1935, the brick post office building on Main Street displaced the home of Dr. Rafter. The village needed 12,000 square feet of space and a frontage of 80 feet on a main street. The new Hamburg Post Office opened on February 24, 1936. In the early days of White's Corners, mail came to the village from Water Valley and then from Abbott's Corners, now Armor. The first village post office was on the site of the Washburn Tire Store. The post office moved next to Kopp's Hotel, on the corner of Main and Buffalo Streets, and then to Young's Drug Store, the Bank of Hamburgh building on Main Street, and the Hamburg Finance Building for 12 years. Hamburg's first airmail flight was on May 19, 1938; the mail was flown from Hamburg to Buffalo.

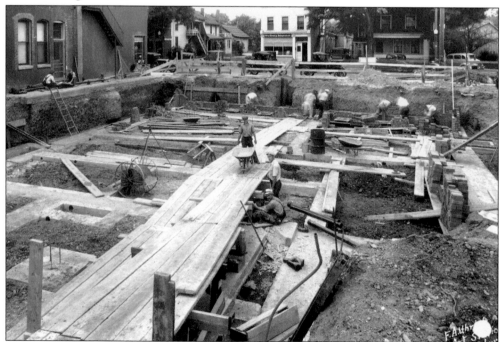

This unusual photograph shows the foundation of the post office building being constructed. The old office of the *Hamburg Independent* newspaper is visible across Main Street. (Courtesy Hamburg Historical Society.)

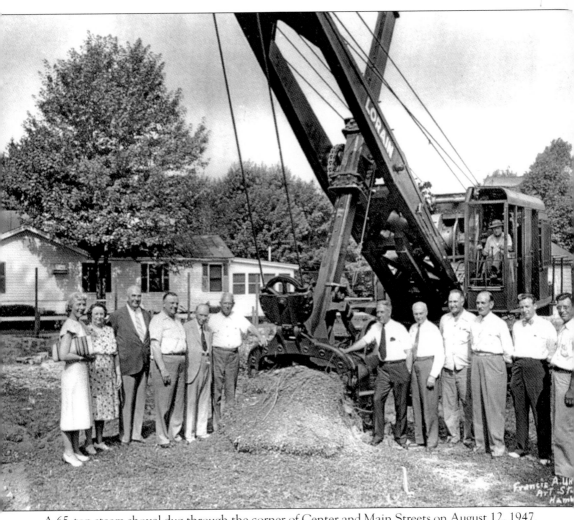

A 65-ton steam shovel dug through the corner of Center and Main Streets on August 12, 1947, to begin construction of the two-story New York Telephone Company building. From left to right are Helen Faux Allen of the *Hamburg Sun*; Jenny Myers, chief telephone operator; Myron Dunlavy; Norman Haas, police chief; Joseph Leach, town clerk; Alfred Drescher, mayor; J.W. Kideney, architect ; Frank Ward; Charles Rodehaver; F.A. Willard; Dudley Ince; and Charles Strouse. (Courtesy Hamburg Historical Society.)

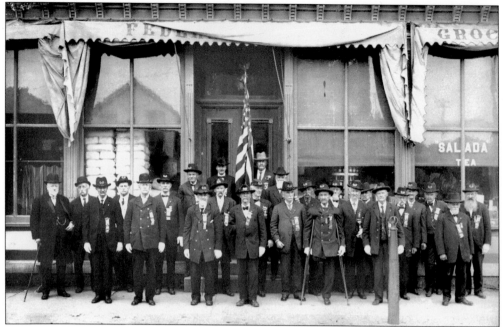

Many Hamburg men joined the 116th Regiment of New York State Volunteers and the 98th Militia and served in the Civil War. The first to lose his life in battle was Charles Buchmueler, who died in 1862 in the battle of Fair Oaks, Virginia. In 1884, long after the Civil War was over, Hamburg veterans organized a Grand Army of the Republic (GAR) post and named it the Nathaniel J. Swift Post after a soldier of the 116th who was killed at the Battle of Plain Store in Louisiana. Shown are Hamburg's GAR members assembled in front of Federspiel's Grocery Store, on South Buffalo Street.

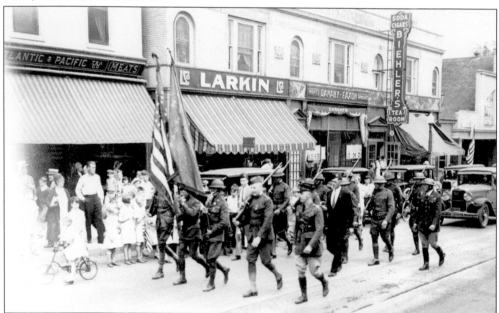

World War I doughboy veterans march past the Larkin Company shop, Danahy-Faxon meat and grocery store, and Biehler's Tea Room, in the first block of Buffalo Street in the 1920s era.

The 1931 Memorial Day ceremonies were elaborate. American Legion members visited the Catholic cemetery, then Armor, decorating graves of fallen soldiers. A parade formed at the Odd Fellows temple and marched to the Lake Street Park for services at the monument erected by the Women's Relief Corps. Ceremonies followed at Prospect Lawn Cemetery and then the parade returned to the Odd Fellows temple. Commander Raymond F. Emerling of Hamburg Post No. 527 asked all Legion members to attend, as "we have not long to march with the veterans of the Civil War." Shown from left to right in dark suits are Hamburg's last five Civil War veterans: Eugene Frink, Joseph A. Taylor, Fred Henn, Conrad Glasser, and Charles Duke. Taylor was present with Gen. Ulysses S. Grant at the Appomattox Courthouse on April 9, 1865, when Gen. Robert E. Lee surrendered. Duke was born on September 14, 1841, on a ship crossing the Atlantic Ocean; he was Hamburg's last living Civil War veteran when he died at his home, 192 Lake Street, on June 24, 1939, at the age of 97. As a corporal with the 116th Regiment that fought at Gettysburg, Duke partially lost his hearing as a result of a cannon blast.

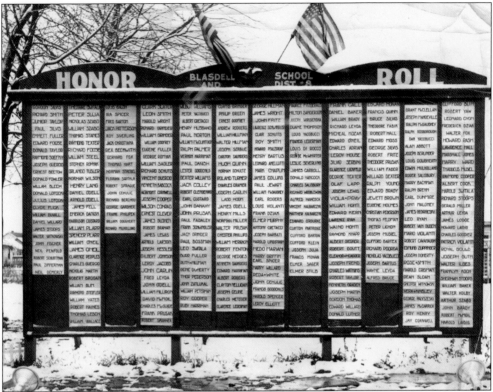

Blasdell's Honor Roll of names of people in the armed forces stood on Lake Avenue near the Presbyterian church. The Harry Clifton American Legion Post erected this tablet. The *Blasdell Bulletin* was sent to all Blasdell school graduates who were in the service from 1943 to 1946.

Like most American communities, Blasdell, Hamburg, and Lakeview erected honor rolls listing the names of local citizens who were serving in the armed forces during World War II. Sts. Peter and Paul Church and the Methodist church erected their own honor rolls. Hamburg's large wooden tablet in Village Park listed servicemen and servicewomen from the entire town. Assembled in five sections, it was dedicated in 1943. A five-star service flag hung in the home of Mr. and Mrs. James McAllister of Windover Drive, as they had five sons in the service: Arch, Robert, Jack, Henry, and Walter McAllister. (Courtesy Hamburg Historical Society.)

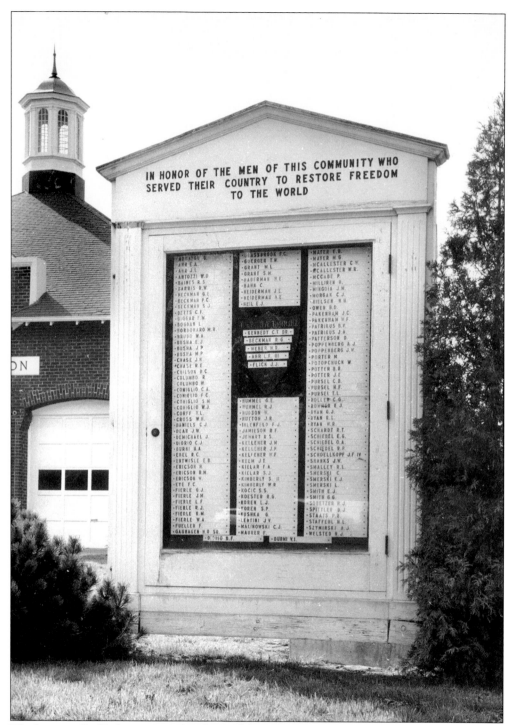

The honor roll of Lakeview stood in front of the Lakeview Fire Hall and listed 129 soldiers and sailors, including many relatives; for example, three Beckmans, three Bushas, three Ericsons, six Fierles, three Kellehers, three Pursels, and three Scheidels. Casualties from Lakeview included C.T. Kennedy, B.G. Beckman, W.R. Weber, L.F. Ahr, and J.J. Flick.

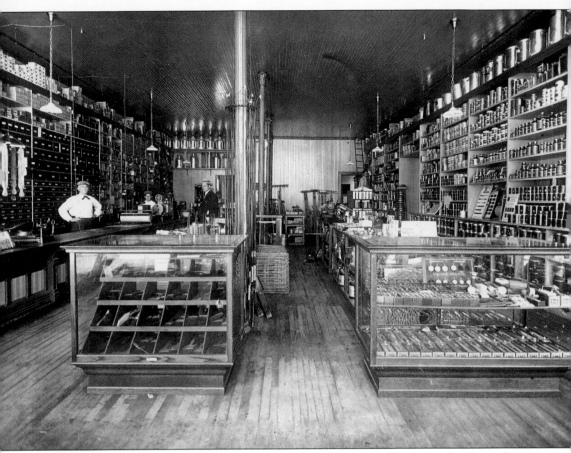

Long before chain hardware stores put the independents out of business, the Kronenbergs ran this neat and organized hardware store. With bin after bin of anything one might need, the store had a cheerful and informed staff and honest prices. The store emphasized family relationships among the staff. In 1948, the Kronenberg store held its 100th anniversary celebration, which included a dinner for 300 employees and guests at the Hotel Hamburg. A booklet, *100 Years of Growth Thru Service*, was published for the anniversary; it describes the contributions of four generations: Joseph, William, Charles B., and Charles W. Kronenberg. Joseph Kronenberg was born in Lucerne, Switzerland, in 1820 and came to Hamburg to establish his tin shop in 1848. He married Fannie Jurick, and their son William was born in 1856. In 1882, the shop was destroyed by fire; in 1884, it was rebuilt and William Kronenberg went into partnership with Newton Fish. Charles B. Kronenberg joined the store in 1905 and became president of the Bank of Hamburgh after his father died in 1930. (Courtesy Hamburg Historical Society.)

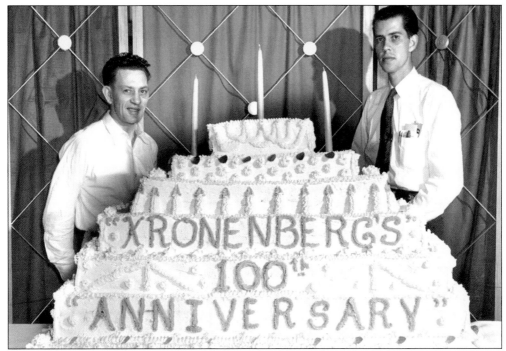

A huge birthday cake celebrated Kronenberg's first decade of business, from 1848 to 1948. Vice-president Charles W. Kronenberg (right) was an artillery officer during World War II and a member of Hamburg's Masonic Lodge, the Chamber of Commerce, and the American Legion. (Courtesy Hamburg Historical Society.)

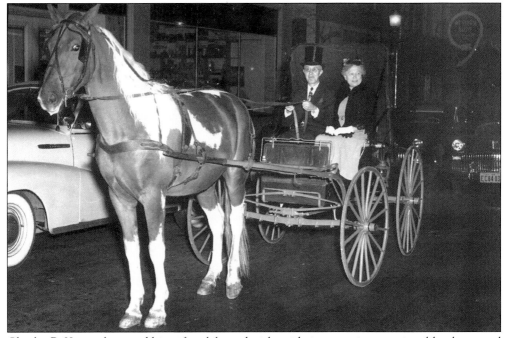

Charles B. Kronenberg and his wife celebrated with a ride in an antique carriage like those used in 1848, when Joseph Kronenberg opened his tin shop in Hamburg.

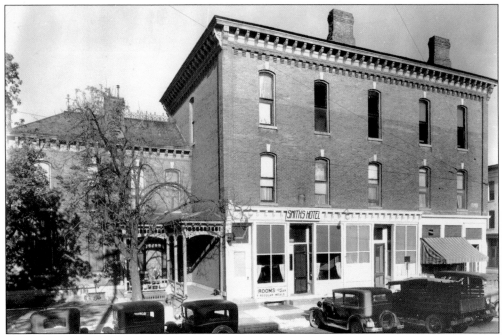

The old Federspiel's Grocery Store, on the corner of Main and Buffalo Streets, housed many businesses including Eckhardt's Hotel and Smith's Hotel, both of which featured rooms and regular meals at daily or weekly rates.

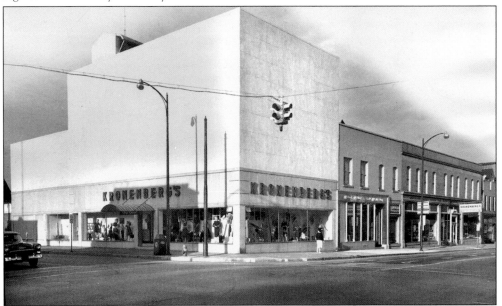

This view of Kronenberg's Store, on Main and Buffalo Streets, shows the business in the early 1960s, when the property was for sale. This store is actually the old Federspiel's Grocery Store, shown in the photograph above. After the construction of the Hamburg Village Plaza and the Southshore Plaza, on Southwestern Boulevard, customers could drive to the new plazas nearby and, as a result, Kronenberg's store closed on March 18, 1961, after nearly 113 years of business. (Courtesy Hamburg Town Historian.)

The arrival of automobiles drastically changed Hamburg. All the service stations, parking lots, and highways have given freedom to Hamburg residents—but at a high cost to the village. In 1951, city planner and traffic expert Robert Moses visited and surveyed the highways and parking facilities. He said, "Every community finds itself today in the middle of the full-fledged crisis of the motor age. Hamburg is no exception." Hamburg had numerous automobiles, but neglected to plan for them when they were not in use or when they were going through the centers of activity.

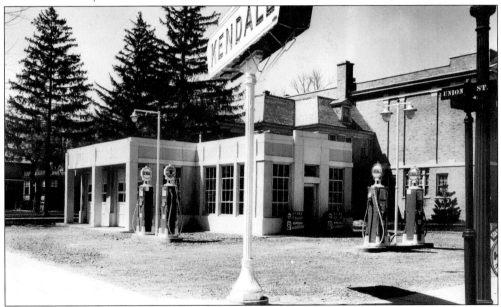

This early Kendall gasoline station stood at the corner of Union and Buffalo Streets until it was demolished for the building of the Rosewood Seniors Home. This corner was the original property of the Peffer House of businessman Jacob Peffer and his wife, Polly. Their altered home can be seen behind the service station, with the newer Masonic temple attached to it. (Courtesy Hamburg Historical Society.)

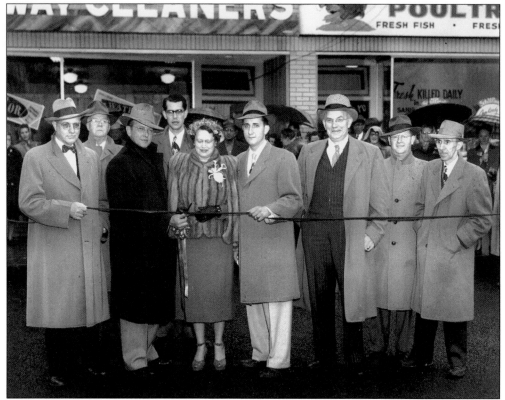

The Hamburg Shopping Center, built at a cost of $550,000, attracted 17,000 visitors to its 13 new stores on opening day, April 12, 1951. Dignitaries for the ribbon cutting ceremony, from left to right, are J. Leo Goodyear, Hamburg village mayor; Sydney Brown; Norman G. Biehler, developer; Charles W. Kronenberg; Evelyn Biehler; Dr. Joseph D'Angelo; Frank Dorn, plaza leasing agent; Walter K. Connell; and Raymond Emerling Sr., Hamburg town supervisor. The shopping center, was originally intended to have a roller rink in the basement of one of the stores. (Courtesy Hamburg Town Historian.)

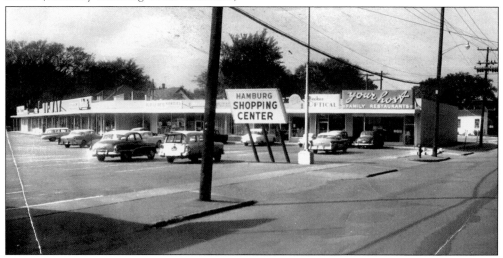

The north side of the Hamburg Shopping Center was built in 1957.

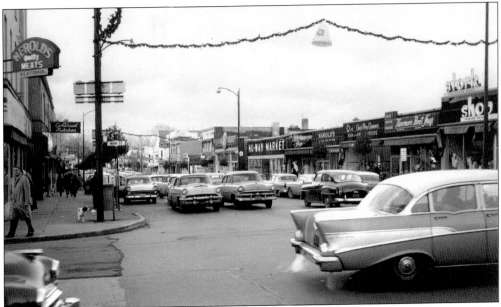

The shopping district of Hamburg village was still robust at Main and Buffalo Streets in 1957. This photograph shows Herold's Meat Market, the Colonial Kitchen, the Palace Theater, Blaine Real Estate, the A & P Supermarket, the Nu-Way Market, the Cara Ann Shop, Harold's Boys & Men's Wear, Clock Wise Cleaners, the Kenmore Boot Shop, and the Stork Shop, on Buffalo Street.

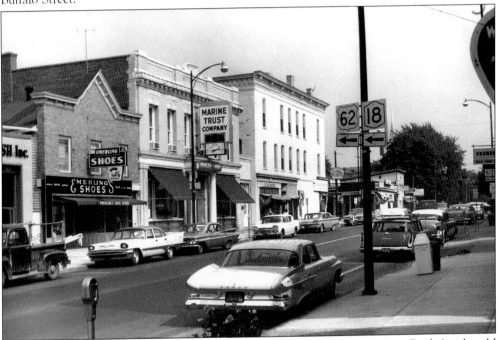

This 1960 view along Main Street shows Emerling's Shoes, the Marine Trust Bank (in the old Bank of Hamburgh building), and the Bunting Block building, with Herold's Meat Market on the corner. The twin spires of Sts. Peter and Paul Church are barely visible in the distance. (Courtesy Hamburg Town Historian.)

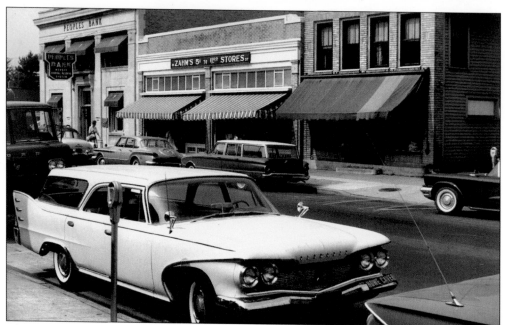

This 1960 photograph, taken farther down Main Street, shows the Peoples Bank and Zahm's 5 cent to $1.00 Store. Later, Moore's Men's Wear moved from Buffalo Street to the Zahm's building. Hamburg's main commercial streets had parking meters and congested parking. (Courtesy Hamburg Town Historian.)

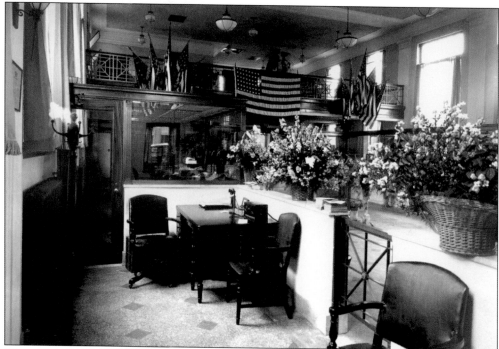

The interior of the Peoples Bank was designed to remind customers of an ancient treasure vault. Visitors would push a huge bronze revolving door before they saw the mezzanine and the bank's huge vault, with its 10-ton door. (Courtesy Hamburg Historical Society.)

Hamburg's first armed bank robbery took place on September 4, 1947, in this driveway between the Huson Hotel and the Peoples Bank. John B. Weber, assistant cashier of the Bank of Hamburgh, was carrying a bag with $27,500 cash and $617.93 in money orders on his way to the Buffalo Federal Reserve Bank when one robber wearing sunglasses jammed a pistol into his ribs and another held a machine gun. The robbers took the bag of money and escaped in a 1941 Buick sedan, zigzagging through village streets at high speed. Norman P. Haas, police chief, usually was aware when Weber was carrying large amounts of cash; however, on that Tuesday morning, Haas was across the street from the crime, talking to Mulholland, one of his officers. After the robbery, Weber and Bill Firth and chased the robbers down Lake Street. Within minutes of the crime, insurance agent Fred Hauck arrived at the bank and handed bank president Charles Kronenberg an insurance check in record time.

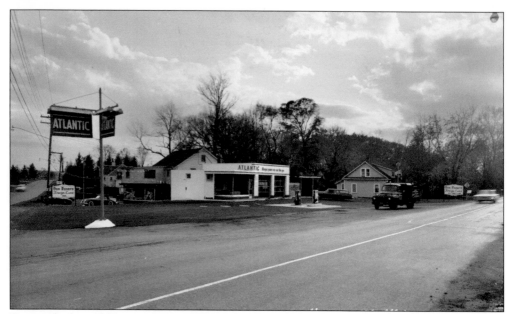

During the late 1950s, gas stations appeared on most of Hamburg's corners. These construction photographs from the Atlantic Company show the new white filling stations at major highways, usually with few automobiles shown. These stations are generally quite altered now, and the sites are quite developed. This station, on the corner of Clark Street and McKinley Parkway, was built in 1959.

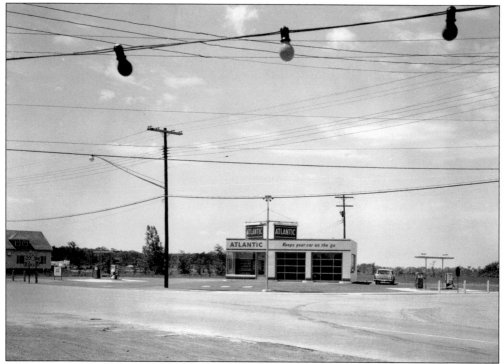

This Atlantic Station on South Park Avenue at Bayview was built in 1958. This stretch of highway has become one of Hamburg's most congested and dangerous intersections.

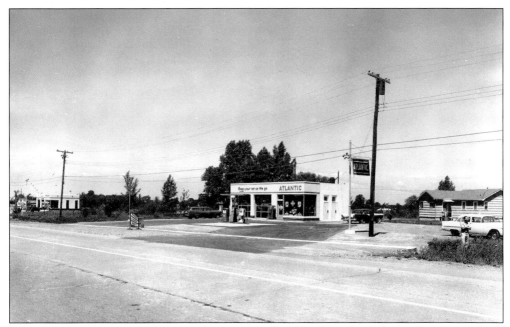

Camp Road was a quiet highway in the summer of 1958, when this Atlantic Station was built between Columbia and Dartmouth Streets. Another new gas station is located down the road, and a new ranch house stands behind the gas station.

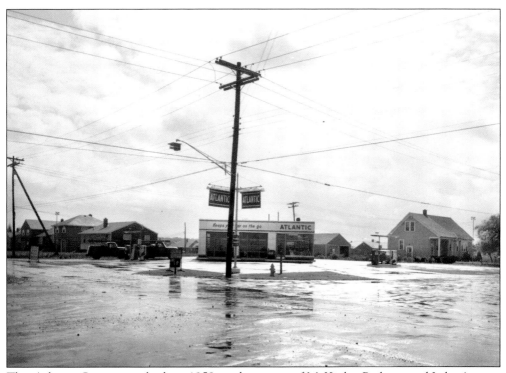

This Atlantic Station was built in 1958 on the corner of McKinley Parkway and Lake Avenue in Bethford. Since this photograph was taken, new homes have been built in this area.

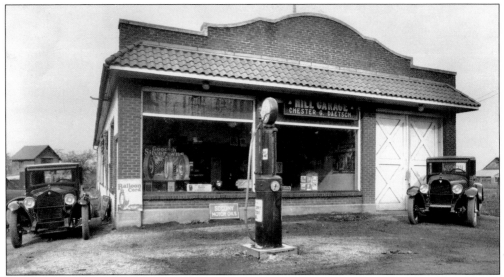

Chester G. Daetsch ran the Hill Garage, high on the west side of Pierce Avenue on the way to Water Valley. Daetsch learned automobile maintenance beginning in 1911, when he worked at Hamburg's first garage, run by Daniel Broderick. He drove the first truck transporting goods in the village of Hamburg. This original garage with the curved roofline was built in 1922. Daetsch purchased the property of the Hines Brothers Box Factory in 1938 and expanded the building to include an automobile showroom. He sold Dodge and Hudson automobiles, called "America's safest car," Silver King tractors, and Bolen garden tractors and power lawn mowers. His wife, Wanda Daetsch, painted murals on the showroom walls and wrote two books. (Courtesy Hamburg Town Historian.)

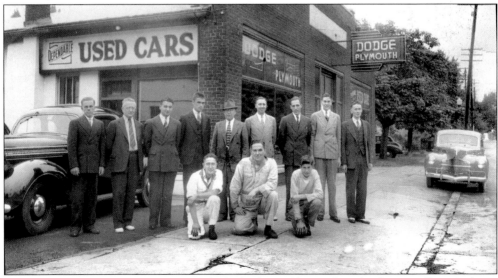

At one time, Hamburg had 13 automobile dealerships selling 16 brands of cars. William Haberer ran a Dodge dealership at 266 Buffalo Street. He and his brothers founded a coal and building supply business in 1906 and opened the Dodge dealership in 1919. After Haberer died in 1946, his son continued operating the business until it was sold to Frank P. Butler of Niagara Falls in September 1960, when it became Butler Dodge. Emma Kloepfer Haberer, with her parents, ran Kloepfer's Hotel on Main Street. Her brother John Kloepfer had a successful banking career.

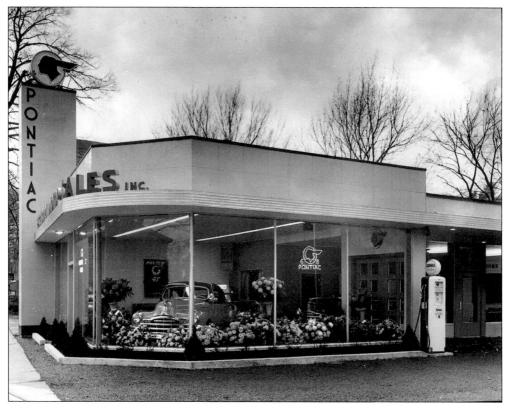

Pontiacs were sold at Eschborn Motor Sales, at 95 Main Street. This property was the garage of Howard Mohr. Built by Alvin C. Eschborn, the modernistic tile-faced building opened in November 1948, attracting 2,500 guests. The showroom had room to display three new Pontiacs; the parts department and garage were in the rear.

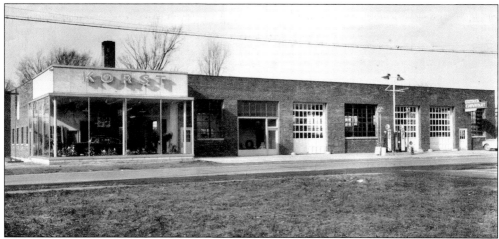

Donald B. Korst founded his Chevrolet dealership on Buffalo Street near Union Street in 1931. In January 1949, the dealership moved to its new building at 260 Lake Street, with a grand opening that attracted 3,000 people. The two-tone green showroom boasted a red tile floor and the latest in fluorescent lighting. Korst Chevrolet started driver-education classes at Hamburg High School in 1947. (Courtesy Hamburg Town Historian.)

The Wilber Pierce house stood on the corner of Buffalo Street at Oliver Place; it is now the site of a chain coffee shop. Born in Armor in 1827, Oliver Pierce married Helen M. Comstock c. 1893. He and his wife had three children, Frank, Lyman, and Wilber. He owned a large tract of land on the street, which was later named after him. (Courtesy Hamburg Historical Society.)

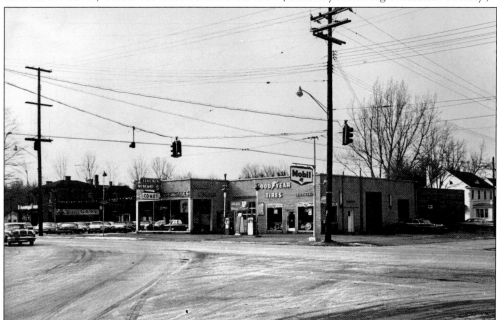

This 1962 photograph shows an odd mix of old and new architecture on Buffalo Street at North Street. The automobile dealership and service station stands between the Wilbur Pierce home, on Buffalo Street, and the homes on North Street. The automobile dealership became Village Lincoln-Mercury, Dan Mullan Lincoln-Mercury, and then a pharmacy. (Courtesy Hamburg Town Historian.)

Three

SOCIAL LIFE

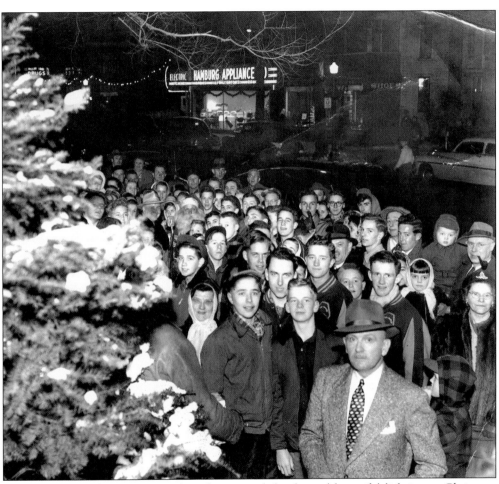

The tradition of decorating Hamburg homes with bright and beautiful lighting at Christmas began in 1928. The *Independent* weekly newspaper and the Electrical League of the Niagara Frontier ran a contest asking homeowners to create a pageant of colored lights at holiday time. The newspaper said that Hamburg citizens did not need an inducement to spread the spirit of goodwill outdoors to cheer the lonely passerby, but that a little friendly rivalry would help whet ingenuity and bring out more unique and artistic effects in lighting. That winter, the lights turned the village into a "veritable fairyland." This photograph shows Hamburg postmaster Al Tallman in front of the crowd at the Christmas tree–lighting ceremony.

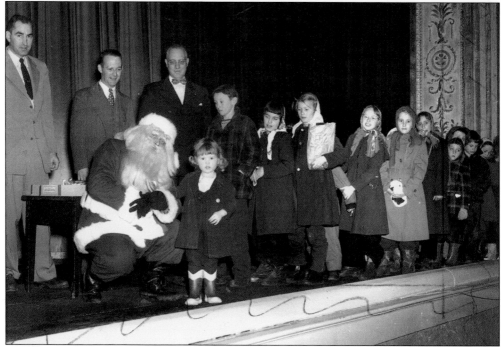

Hamburg's banks held impressive Christmas parties for the area's children. William Kronenberg, president of the Bank of Hamburgh, started the tradition of having Santa Claus give orphans and children a present at the Palace Theater. The Peoples Bank gave children boxes of Christmas candy, and in 1930, some 1,000 children packed the Palace Theater for their gifts and a special film given by George Biehler. In this later photograph, from left to right, Walter Steffan, George Hebard, and Leo Goodyear help Santa Claus.

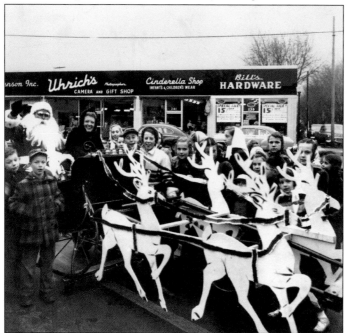

The Santa Parade of 1953 culminated with the arrival of St. Nicholas and his sleigh, led by four of his eight tiny reindeer. In 1954, Santa arrived by helicopter. The row of shops on Buffalo Street was originally attached to Kopp's Hotel when the tavern business declined during Prohibition. The hotel was razed, but the row of stores survived. (Courtesy Hamburg Town Historian.)

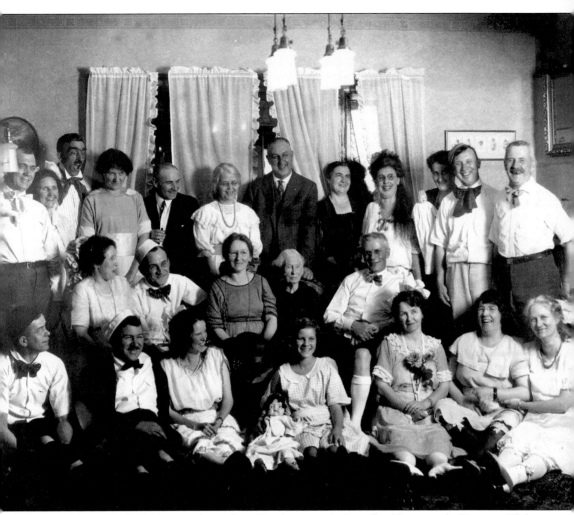

Numerous social clubs were formed in Hamburg, including the Nineteenth Century Club, comprising 19 women, the Masons, the Odd Fellows, the Beulah chapter, the Women's Relief Corps, the Women's Christian Temperance Union, garden clubs, the Hamburg Women's Club, the Antiques Study Group, the Knights of Columbus, the Benevolent and Protective Order of the Elks, the Moose, the Lions Club, the Rotary Club, the Kiwanis, the Business Men's Club, the Hamburg Chamber of Commerce, and others. In this 1922 photograph of the Linger Longer Club, the men dressed as boys and the women dressed as girls. Shown from left to right are the following: (front row) William Taylor, Dr. George Learn, Nellie Learn, Loretta Dudley, Blanche Taylor, Gertrude Robinson, and Helen Mendonsa; (middle row) Nellie Quimby, Wilbur Quimby, Eliza Dudley, Mrs. Schmidt, and Colin Dudley; (back row) Henry Stratemeier, Mrs. Stratemeier, Arnold Titus, Clara Titus, Manuel Mendonsa, unidentified, Carlton Eno, Lottie Eno, Della Ramsdell, Ella Colvin, William Ramsdell, and Dr. Robinson. (Courtesy Hamburg Historical Society.)

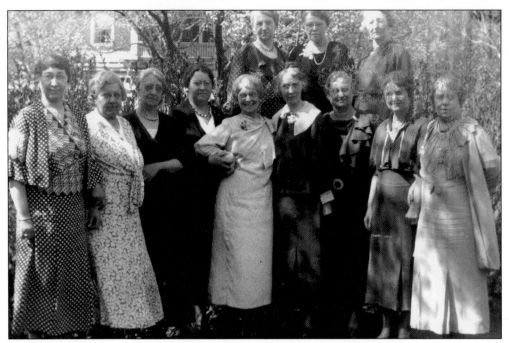

Taking a break from cards to pose for this photograph are, from left to right, members of Gertrude Richardson Tooley's bridge club as follows: (front row) Ella Bartholomew, Clara Churchill, Gertrude Tooley, Ethel Van Pelt, Martha Parsons, Alice Newton, Kate Fosdick, Mrs. Stratemeier, and Kate Pierce; (back row) Mabel Reed, Helen Bourne, and Eliza Dudley. Tooley was the widow of noted photographer Everett A. Tooley, who served as the official photographer of the Erie County Fair before his untimely death in 1907. (Courtesy Hamburg Historical Society.)

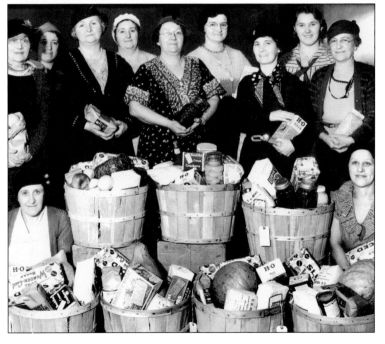

Hamburg's Women's Relief Corps is best remembered for erecting the Soldiers Monument, in the Hamburg Village Park. However, the group performed other services as well, such as this food drive. Only the two seated women are identified: Mary Shoemaker (left) and Marion Lapp. (Courtesy Hamburg Historical Society.)

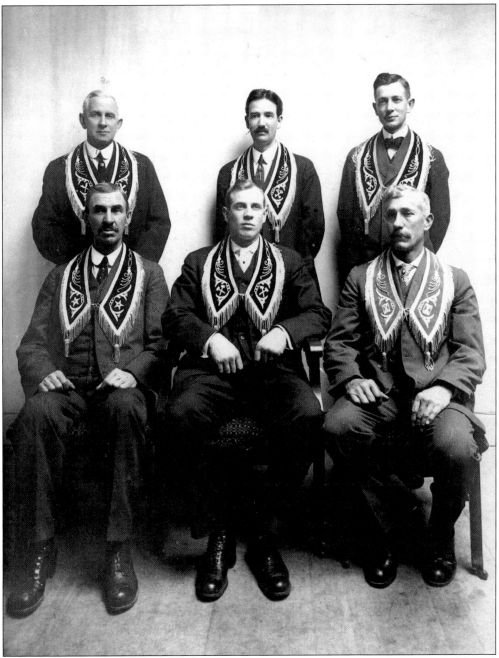

The officers of Hamburg's Triumph Lodge, International Order of Odd Fellows were, from left to right, as follows: (front row) Alec Parks, Cecil Bruce, and Jacob Machmer; (back row) Perry Thorn, William Gale, and Seton Newell. The Odd Fellows temple was the setting for many of Hamburg's large gatherings. Members lived their motto: "Friendship, Love, and Truth." (Courtesy Hamburg Historical Society.)

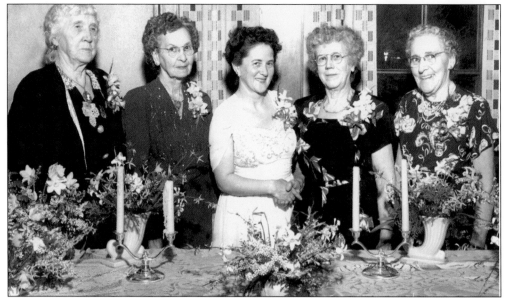

The Beulah Chapter of the Order of the Eastern Star was an organization for the female relatives of Hamburg's Master Masons, chartered in 1899. It was named after Beulah Thorn Newton, sister of Perry Thorn, who served as master of Hamburg's Fraternal Lodge No. 625. Shown celebrating the chapter's 50th anniversary on May 3, 1949, are, from left to right, past and present matrons Laura Woodruff, Blanche Taylor, Eleanor Jennings, Lovinia Robbins, and Carrie Abbott. (Courtesy Hamburg Historical Society.)

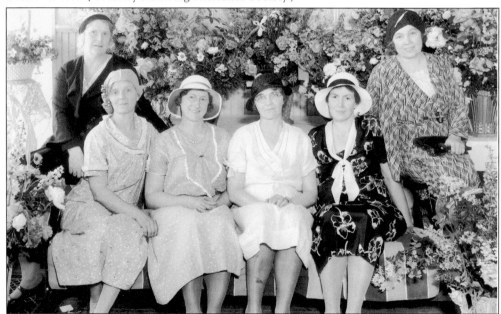

The Hamburg garden club was founded in 1924, with Mrs. Clifton Flenniken as its first president. Greenhouse owners Guenther and Minekime encouraged the group to hold an annual flower show in Kopp's Hotel. Prominent members of the club, from left to right, are unidentified, Mrs. Henry Sipprell, unidentified, Mrs. Dougan, Mrs. Marcus Steese, and Mrs. Kathryn Sharp. (Courtesy Hamburg Historical Society.)

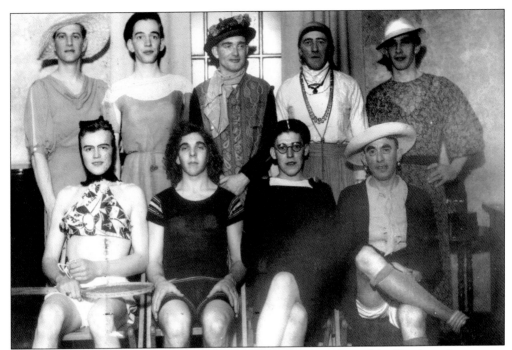

Dressed up as women for the 1938 Halloween party, these members of the Hamburg drum corps, from left to right, are as follows: (front row) Milton Agle, Bernell Thurber, Al Mammoser, and Joe Dole; (back row) Al Archer, Loren Hahn, "Red" Sipprell, Archie Taber, and Lou Nesbitt. (Courtesy Hamburg Historical Society.)

The wedding portrait of Andrew Mammoser and Frances Rebman was taken on September 16, 1919. The flower girl was Florence Winkelman Thiel, and the attendants standing, from left to right, are John Dunn, Albert Mammoser, Ida Enser Mammoser, and Evelyn Dole Dunn. Albert Mammoser is also shown above in a lighter moment, dressed as a woman for Halloween. (Courtesy Hamburg Historical Society.)

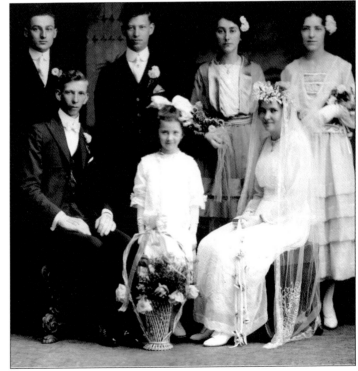

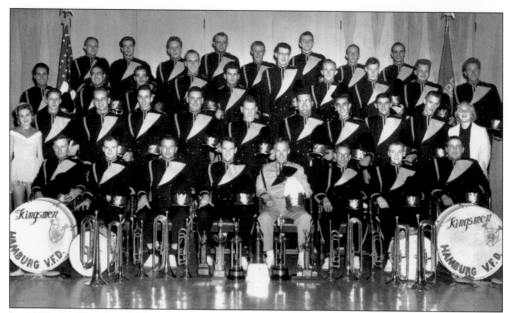

In 1927, the Hamburg Volunteer Fire Department organized a drum and bugle corps to march in local parades. The members, all firemen, played drums, bugles, fifes, and bells. In 1955, the corps became known as the Kingsmen. This photograph shows the members in 1957.

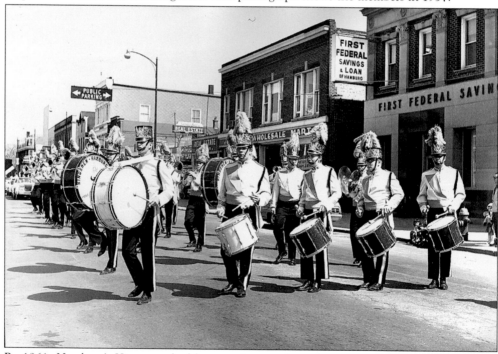

By 1961, Hamburg's Kingsmen had become famous throughout western New York. In 1968, the Kingsmen separated from the fire department so that they could march in national competitions. The group first allowed women members in 1972. Hamburg declared the week of July 18, 1977, Kingsmen Week to celebrate the corps' golden anniversary. The Kingsmen are shown performing on Main Street.

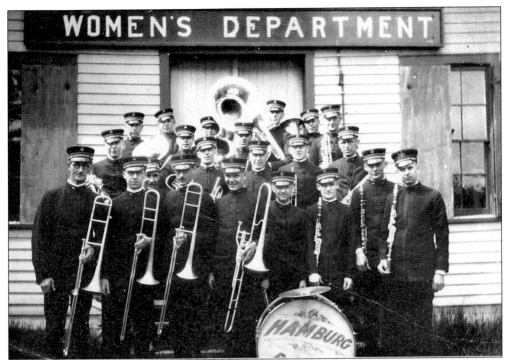

The Hamburg band was organized in 1898. Among the charter members were Simon Rose, Jacob Busch, Roy Clark, and Albert Dreschler, who played the tuba at age 17. Rose had played with a band in the Barnum and Bailey Circus. By 1919, Drescher was the band director and the musicians practiced in a room over his garage on Pine Street. (Courtesy Hamburg Town Historian.)

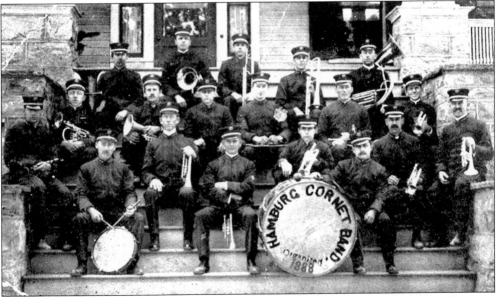

Hamburg has long been a musical community. The first uniformed band was the Hamburg cornet band, organized in 1870. Simon Rose led the cornet band, and Zachary Taylor and William Kronenberg were members.

49

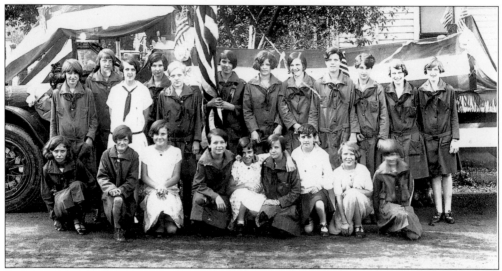

Girl Scouts from Blasdell pose beside a parade truck on July 30, 1927. From left to right are the following: (front row) Janice Luther, Eileen Schwindler, Winnie Alguire, Gertrude McMoil, Katherine Dunmire, Euphemia McClellan, Grace Kingsland, Edna McMoil, and unidentified; (back row) Edith Kahler, Katherine Rickings, Viola Pray, Margaret Morford, Anna Schummer, Anna Mae McMoil, Mary Jewart, Elizabeth McGaughey, Imogene Jenkins, Ruth Young, and Geraldine McClintock. The summer of 1927 was a great time for parades: a huge firemen's convention celebrated Hamburg's 125th anniversary, and the grand parade on Friday, August 5, 1927, had dozens of marching units. (Photo courtesy of Elizabeth McGaughey Saunders.)

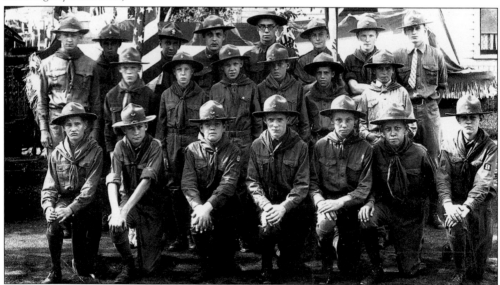

The 1925–1926 Blasdell Boy Scouts, from left to right, are as follows: (front row) George Silvis, Floyd Morford, Charles Jewart, Harrison Custard, Kenneth Alguire, unidentified, and Irwin Shutts; (middle row) John Partridge, Norman Low, Barton Custard, William McGaughey, Clair McGuire, and unidentified; (back row) Walter Horn, unidentified, Peter Kuzmiewicz, Thomas Partridge, Arthur Turner, Clayton Norton, Dan Colley, and Theodore Gabik. (Courtesy Hamburg Historical Society.)

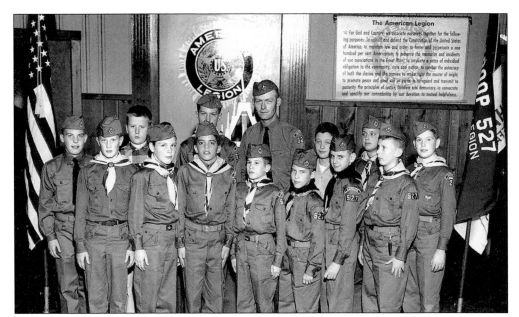

Standing at attention in 1957 are charter members of Hamburg American Legion's Scout Boy Troop 527. From left to right are the following: (front row) Dick Lester, Dave Oberg, Dennis Draudt, Dwight Waterman, Danny Perrin, Foster Young, and Leroy Fiedler; (back row) Butch Bickus, Dave Low, scoutmaster Rollins Low, Steve Hanson, and Billy Southwell. The two boys not in uniform are unidentified visitors.

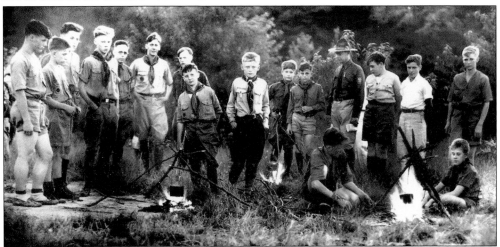

This 1933 photograph shows the boys of Troop 2 holding a contest to boil water outdoors at Ringer's Woods, on Hampton Brook near East Eden Road. The Scouts had to make a fire without matches. The Hamburg Presbyterian Church sponsored the troop. From left to right are the following: (seated) Ed Sawers and Allen Sipperell; (standing) Burton Eckhardt, Frank Spangenberg, Don Bissell, Gardner Low, assistant scoutmaster Donald Bissell, assistant scoutmaster Raymond Bradley, assistant scoutmaster Raymond McCoglin, Fred Sawers, Rollins Low, Neil McClosky, Lester Schummer, Edward H. Sawers, Ben Johnson, Fred McClosky, and Leon Piguet. Hamburg's Troop 9, begun in 1939 at the Methodist church, was led by scoutmaster Earl Soloman and assistant scoutmasters Dendall Danielson and Sherwood Sipprell. (Courtesy Fred Sawers.)

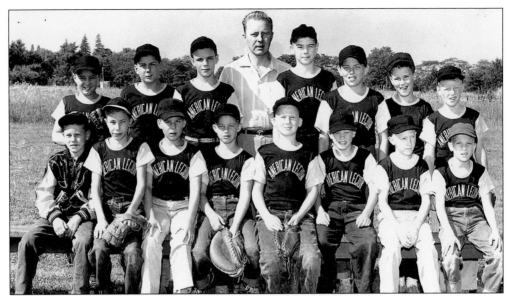

The Hamburg junior baseball league's American Legion 1957 Midget Champs, from left to right, are as follow: (front row) Dave Roberts, Ronny Armitage, Robert Shanks, Don Steth, Leroy Fiedler, Jeff Pearson, Jay Lickliter, and Ralph Berg; (back row) Brian Lewis, Robert Steele, David Cohoon, coach Ray Emerling Jr., Dennis Parks, David Bame, Joe Lickliter, and Jack Emerling. Founded in 1953, the junior baseball league celebrated its 50th year in 2003. (Courtesy Hamburg Village Recreation Department.)

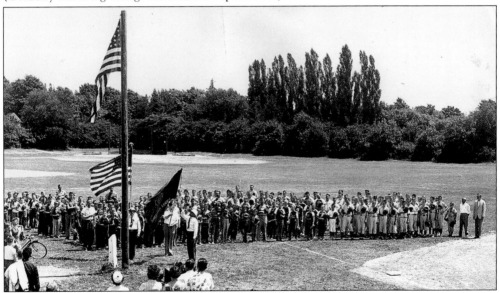

The 1959 season for the Hamburg junior baseball league began on June 25, as the American flag was raised on its wooden flagpole in this ceremony at the American Legion Field. Dick Borton, serving as league chairman, wrote weekly sports articles for the *Hamburg Sun*. A total of 325 boys played baseball during the seven-week season. Mayor James F. Best tossed out the first ball, and spectators followed the local teams with the enthusiasm of major league team followers. Each year, baseball season ended with the Father-Son Awards Dinner. (Courtesy Hamburg Village Recreation Department.)

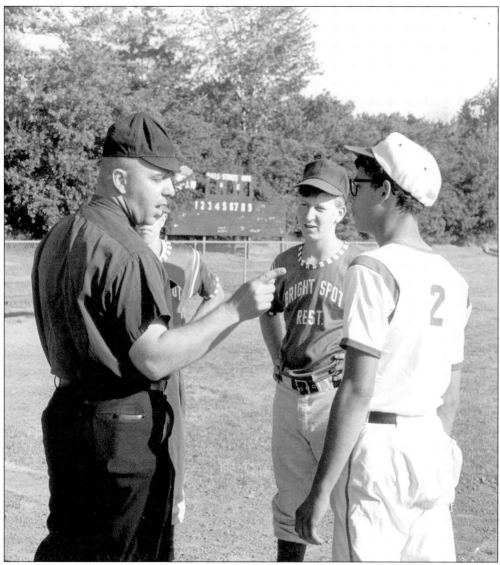

At the American Legion Field in the summer of 1967, the Hamburg junior baseball league umpire gives the ground rules to team captains Brad Stefanon and Bob Ganey of Bright Spot's. The village of Hamburg owns the large triangular property that contains several diamonds in different sizes for peewees, midgets, juniors, and teenage ballplayers. For 50 seasons since 1953, Legion Field has been the scene of star players, broken bats, smiles and tears of coaches and kids, hot dogs from the Snack Shack, and cheers of parents whose youngsters connect the bat to the ball. (Courtesy Hamburg Village Recreation Department.)

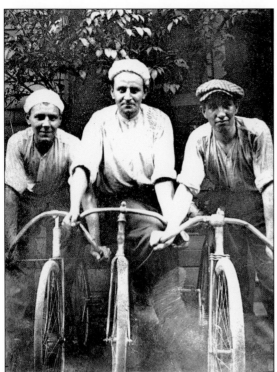

Bicycling has long been a favorite pastime in Hamburg. The Queen City Bicycle Company and the Idlewood Bicycle Factory manufactured bicycles here *c.* 1895. This 1913 photograph shows three young men after a bike trip to Hamburg.

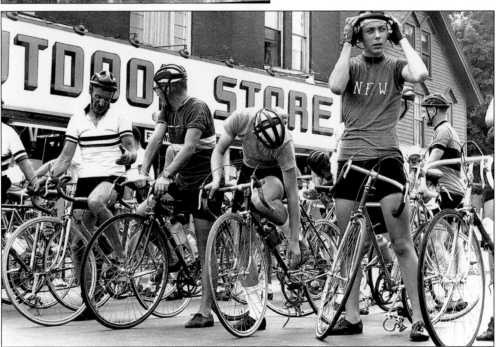

The *Hamburg Sun* newspaper sponsored a 50-mile championship bicycle race on July 11, 1966. A total of 60 international cyclists lined up in front of the Outdoor Store, in the Brendel Building on Main Street. The route took the racers out to the town of Boston and then to Eden, before finishing in front of the *Hamburg Sun* offices on Main Street.

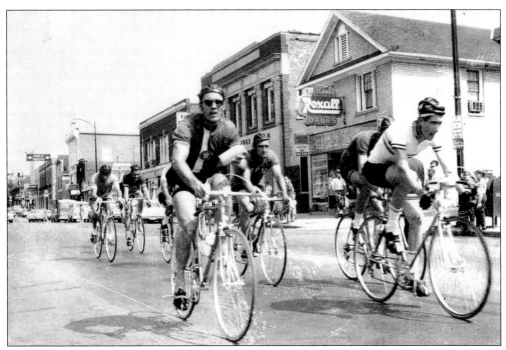

Giovanni Filippin of Italy, far ahead of everybody else, won the race and threw his hands over his head as he glided across the finish line.

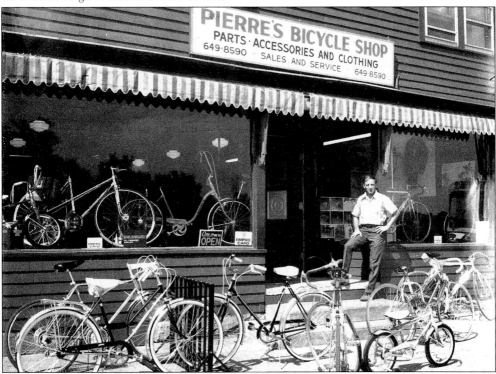

Every great village has a great bicycle shop. Hamburg had Pierre's Bicycle Shop, on East Main Street, owned by Bob St. Pierre. (Courtesy Hamburg Town Historian.)

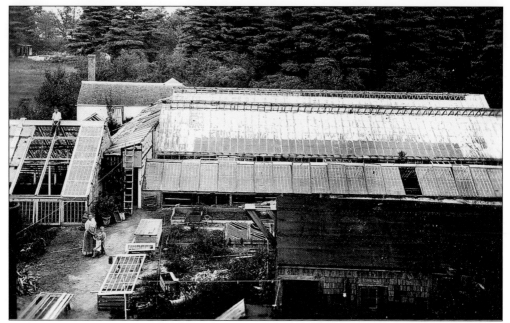

Hamburg was abloom every summer, with gardens, greenhouses, and garden clubs. The Guenther Greenhouse business was located behind the property of Charles and Bertha Guenther, at 144 Long Avenue. The Guenthers, who had 18 greenhouses, left their name on Guenther's Hill, above Eighteen Mile Creek. (Courtesy Hamburg Town Historian.)

This photograph, taken by Fred Guenther, shows blacksmith Ernie Miller in his garden, dressed in his Sunday best. Miller's blacksmith shop was on Center Street near the Hamburg Free Library. His his daughter Viola worked for many years as assistant librarian. (Courtesy Hamburg Historical Society.)

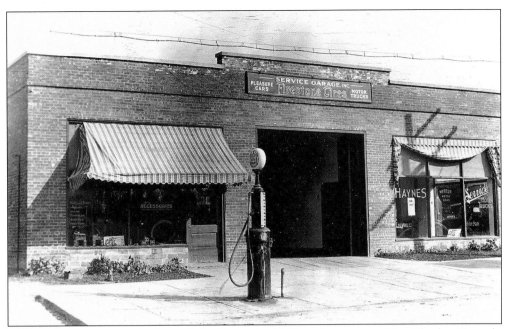

The service garage was built on Lake Street in 1916 and was owned by Charles Daetsch, Fred Barnett, Lawrence Bley, and Ruben Knoche. A second story was added to the building to house the Hamburg Floral Manufacturing Company, founded in 1926. (Courtesy Hamburg Historical Society.)

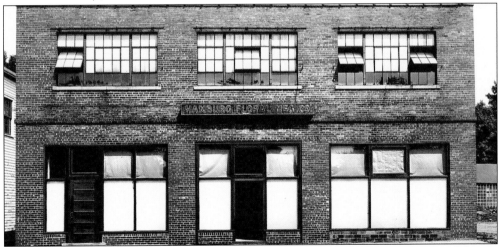

The Hamburg Floral Manufacturing Company was a pioneer manufacturer of artificial flowers and artificial grass. Mr. and Mrs. George Kaderbeck founded the company when they opened a flower shop at 66 Main Street. Their business dropped during the summer because Hamburg homes had so many vibrant gardens that no one needed to buy flowers. The Kaderbecks started making artificial flowers year-round, and they became famous for their boutonnieres, funeral pieces, and bouquets, which were used in the movies. When the Great Depression hit, the company started making artificial grass, with the idea that people would be more likely to spend money on necessities than luxuries. The Kaderbecks sold their fresh flower business to Chris and Arthur Hess c. 1928 and the artificial flower business to Kenneth and Maxwell Eaton in 1934. (Courtesy Hamburg Historical Society.)

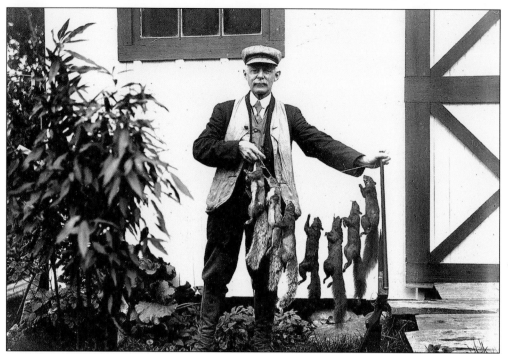

Avid hunter Newton Colvin displays his rifle and the seven unlucky squirrels he shot that day. This photograph was taken in 1910, many years before the People for the Ethical Treatment of Animals requested that Hamburg be renamed Veggieburg in 2003. (Courtesy Collection of Richard Laing.)

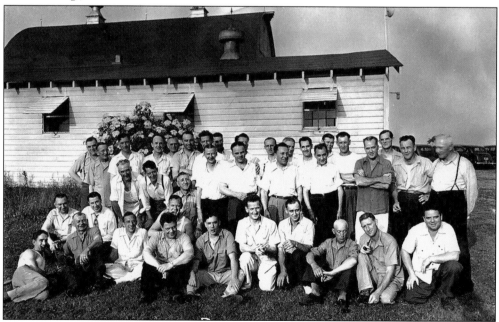

The Blasdell Rod and Gun Club held its summer picnic at Kudara's Grove, on Taylor Road, on June 30, 1946. This club was organized in 1939 at Zuppinger's Hotel, with 21 members, led by John Fritz and Ed Moss. (Courtesy Hamburg Historical Society.)

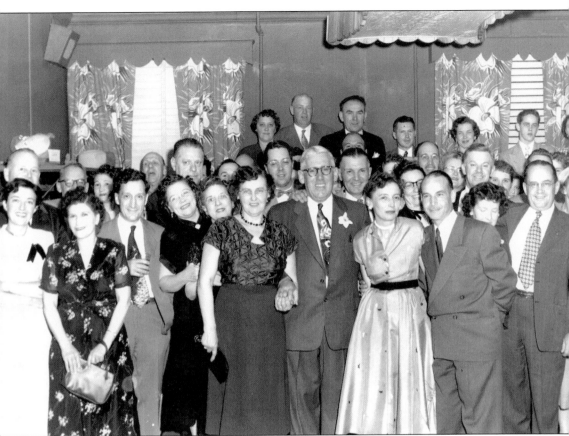

The Hamburg Rod and Gun Club started in 1924 as a conservation club, with trap shooting. The original club disbanded, but years later, Art Vara and young hunters revived the group and built a clubhouse on Lester Burgward's property on McKinley Parkway. Later still, a substantial clubhouse was built on Hickox Road, mostly with materials donated by Bethlehem Steel. The club's first dinner was held in 1924 at the Odd Fellows temple. Attending a later dinner held at the West End Hotel, from left to right in front, are Rita Schumaker, Caroline and Art Vara, two unidentified women, Olive and Burt Smith, Mrs. and Mr. Clifford Crimi, and Maud and Ray Parker. (Courtesy Hamburg Historical Society.)

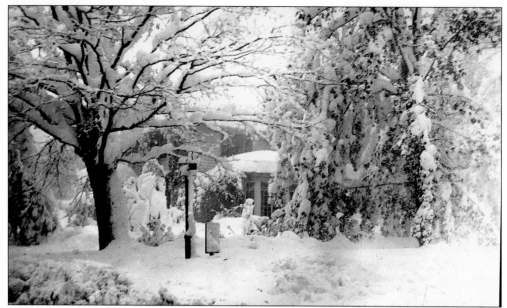

Every Hamburg resident has a favorite winter blizzard story to recount. Old-timers recall the early storm that hit on October 23, 1930, dropping 36 inches of snow and damaging nearly every tree in the village. This view shows Dietrich home, on the corner of Central and Pierce Avenues. (Courtesy Hamburg Town Historian.)

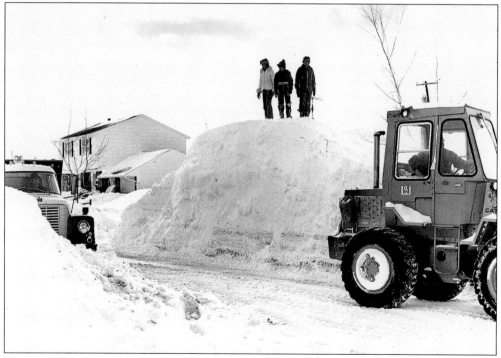

Youngsters like to reminisce about the blizzard of 1977, which struck on Friday, January 28. A girl and two boys stand atop a huge snowbank on Brookwood Drive in Chapel Glen to demonstrate how much snow piled up that winter. (Courtesy Hamburg Town Historian.)

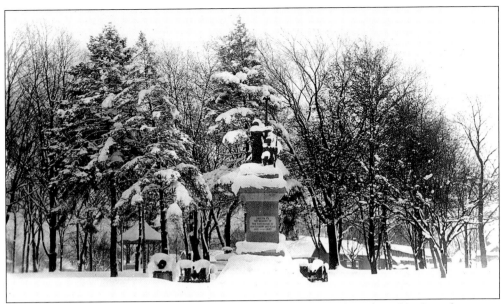

This winter scene shows the Soldiers Monument in Village Park under a blanket of snow on December 19, 1920. The monument was erected in 1914 by the Women's Relief Corps to honor Civil War veterans. (Courtesy Hamburg Historical Society.)

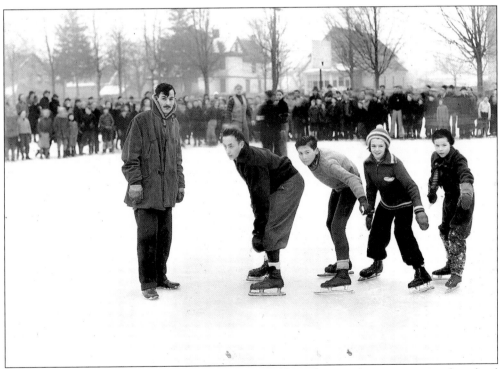

It has been a long Hamburg tradition to flood the field on Pleasant Avenue opposite the school and turn it into an ice rink. Clarence Hahn and his son made the ice rink so that Edward Schweikert (left), the four young skaters, and everyone else could enjoy this winter sport. (Courtesy Hamburg Historical Society.)

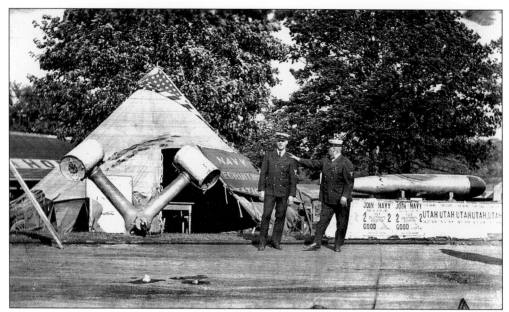

The Erie County Fair has been the highlight of every summer in Hamburg since 1868. Recruiters from the U.S. Navy pitched a tent at the Erie County Fair on September 19, 1919. A torpedo is displayed behind the recruiting officers. (Courtesy Jack Castle.)

Fair midway rides were quite a bit smaller in 1919 than they are today. Among the visible rides are the Frolic and an airplane ride. (Courtesy Jack Castle.)

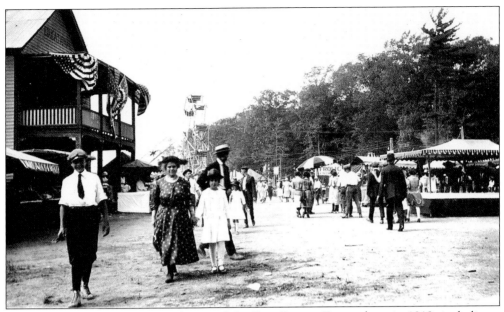

This photograph provides a good view of the Erie County Fair midway in 1919, including a Ferris wheel and a merry-go-round.

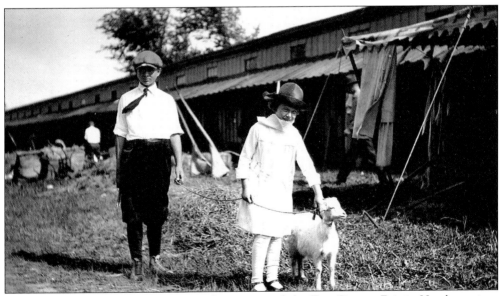

The Erie County Agricultural Society has presented the Erie County Fair in Hamburg since 1868, when Luther Titus offered the use of his harness track for horse racing. Farmers came to have their livestock and produce judged, and city folk came to the country to pet animals like this little lamb. (Courtesy Jack Castle.)

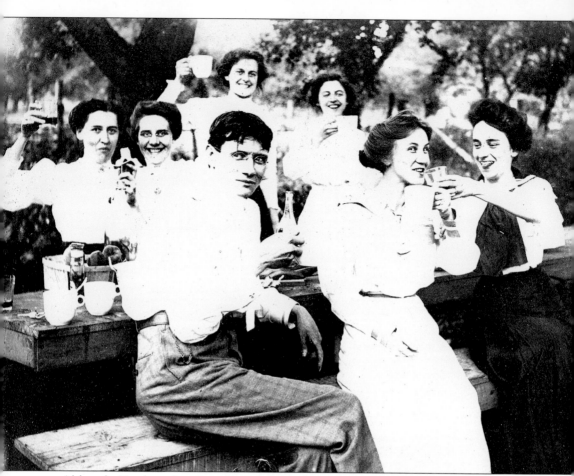

Although Hamburg has long been known for its numerous drinking establishments, not everyone patronized them. In May 1833, a group of 23 young men formed the Hamburg Moral Society and pledged, "We will strenuously abstain from an intemperate use of ardent spirit & intoxicating liquors ourselves, and endeavor to persuade all over whom we have any influence to do likewise." The group kept an eye on the community, and anyone found drinking alcohol—other than for religious reasons or medical purposes—was liable for a trial and fine of 25¢ if found guilty. (Courtesy Hamburg Historical Society.)

Four

THE BUSINESS OF HAMBURG
IS BUSINESS

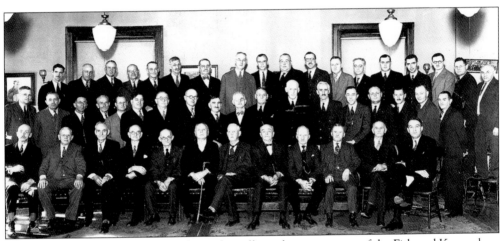

Hamburg businessmen began to gather informally in the upper room of the Fish and Kronenberg building c. 1888, calling their group "the Club." The Business Men's Club was organized on December 26, 1901, with Frank Walker as chairman and John Kloepfer as secretary. Six men were nominated as president—Daniel C. Pierce, Mr. Kendal, John Kloepfer, Newton Fish, Harry Evers, and Perry Thorn; all declined before Pierce finally accepted. The group organized the first library ball, got a new passenger railroad station for the village, ran billiard tournaments in quarters above the Bank of Hamburgh, and held an open house every New Year's Day. The chamber of commerce began on May 1, 1915, with the Hamburg Credit and Commercial Association, which faded and then revived in 1926. The name was changed to the Hamburg Chamber of Commerce in 1927, with Carlton E. Eno as president. The Business Men's Club and the chamber joined forces in 1931, when both organizations were weakening and Hamburg expected to see either "a wedding or two funerals." Shown, from left to right, are the following: (front row) G.B. Abbott, Perry Thorn, Lee Richardson, Charles Wood, unidentified, Allen Monroe, E. Frink, J. Salisbury, C. Kleinfelder, Mr. Hickman, unidentified, and J. Mead; (middle row) C. Flennihen, Joe Danheiser, F. Ueblacker, unidentified, Al Knapp, M. Learn, J. Ueblacker, Mr. Moritz, Mr. Haecker, L. Miller, G. Abbott, Bill Clark, John Kleis, Charles Kronenberg, Don Korst, Alvah Lord, Amos Minkel, and E. Stowell; (back row) C. Barklay, C. Fuller, unidentified, Charles Young, W. Hammond, John Feidt, Carlton Eno, Fred Hauck, E. Fogelsanger, C. Gerkin, H. Baker, Joe Elliott, Don Temple, Willis Hall, G. Frase, Will Abbott, and Henry Kast. (Courtesy Hamburg Historical Society.)

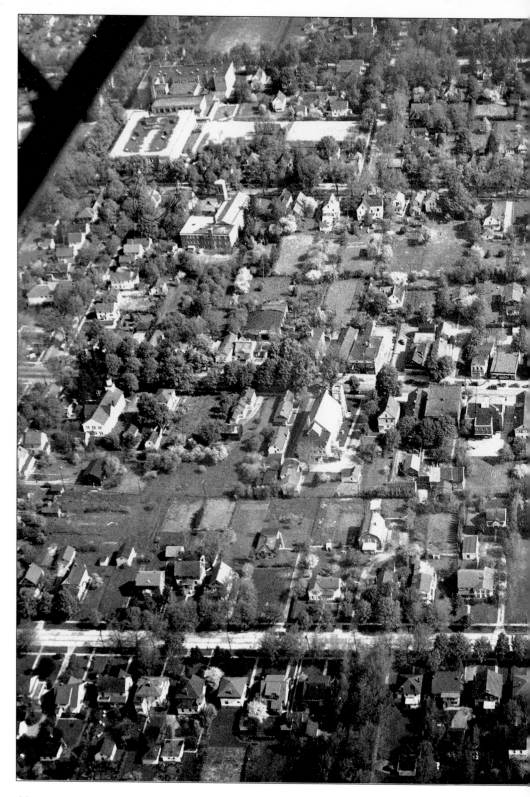

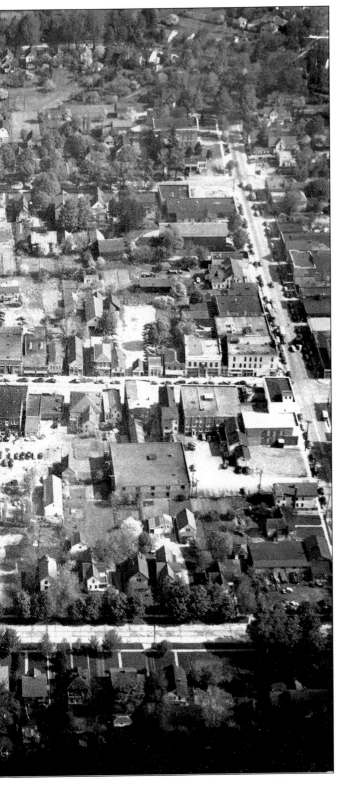

Worth careful study is this 1937 aerial view of Hamburg's business district, taken by the Scheff Studio. The horizontal streets are Long Avenue (below) and Main Street (middle). Buffalo Street (right) and other landmarks are visible, including the old water standpipe, St. James Evangelical Lutheran Church, the Baptist church, and the Methodist church. (Courtesy Hamburg Historical Society.)

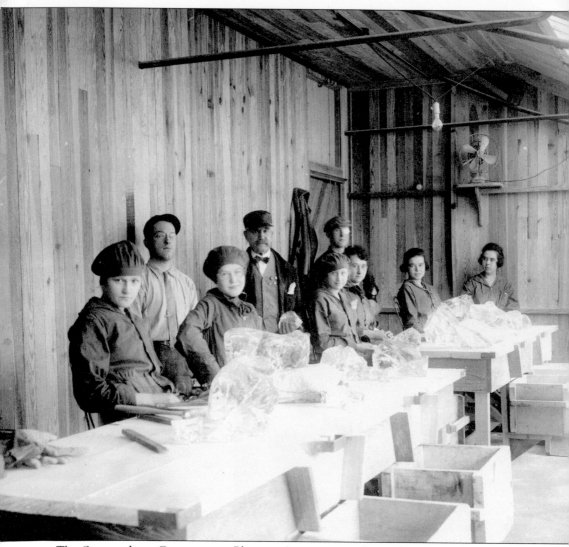

The Spencer Lens Company, on Pleasant Avenue, manufactured optical glass and scientific instruments. Charles A. Spencer formed the company in 1896 on Doat Street in Buffalo, and the Hamburg branch opened in 1916. (Courtesy Hamburg Historical Society.)

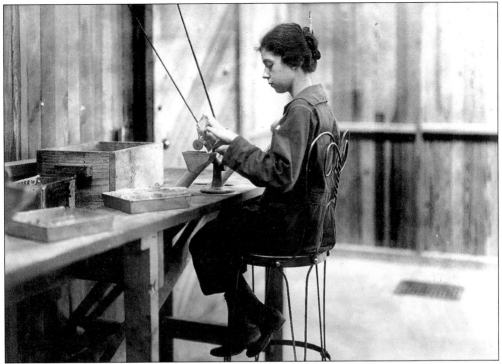

Spencer Glass produced almost a third of optical glass in the United States during World War I. Glass lenses were ground and polished for use in cameras and scientific instruments. (Courtesy Hamburg Historical Society.)

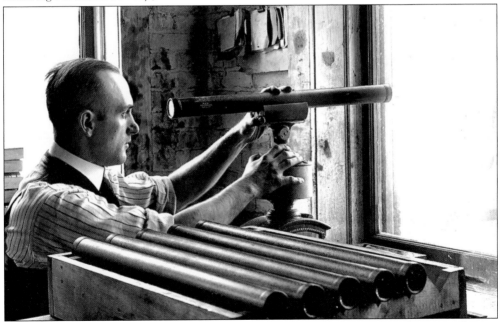

An employee of Spencer Glass is shown testing the lenses in a telescope. Thomas L. Bourne served as superintendent of the glass company; George Morey worked as a chemist; Lee Richardson worked as a molder. (Courtesy Hamburg Historical Society.)

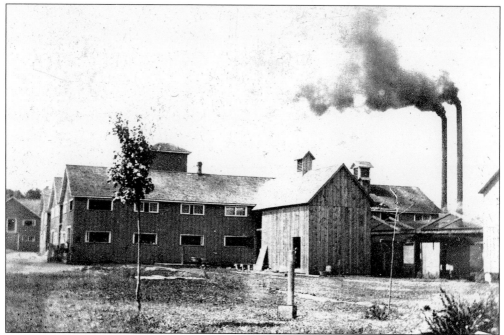

The Hamburg Canning Company preserved the bounty from Hamburg's surrounding fertile farms and shipped it to many parts of the country. Beautifully printed labels were pasted on the cans, sending the name of Hamburg across the country. This 1915 photograph shows one of the 10 buildings used in the canning operations. (Courtesy Hamburg Town Historian.)

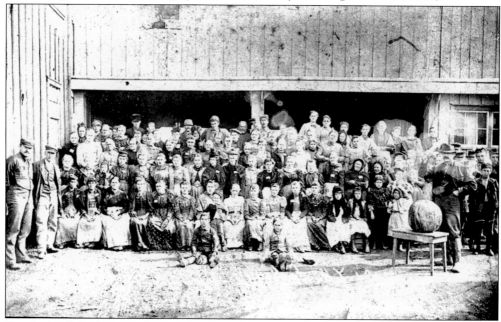

Hundreds of Hamburg residents worked at the Hamburg Canning Company. When the factory whistle blew, workers dropped what they were doing and hurried to process and can the produce. Note the gigantic pumpkin on the table at right in this 1895 photograph. (Courtesy Hamburg Town Historian.)

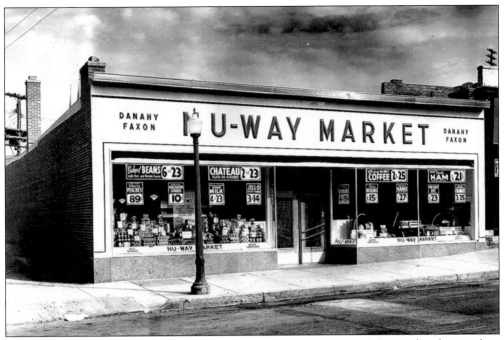

The Danahy Faxon Nu-Way Market opened on Buffalo Street in 1946. It was the place to shop for groceries in the days before huge chain supermarkets. Note the prices: 10¢ for a macaroni dinner and 21¢ for a pound of ham. (Courtesy Hamburg Historical Society.)

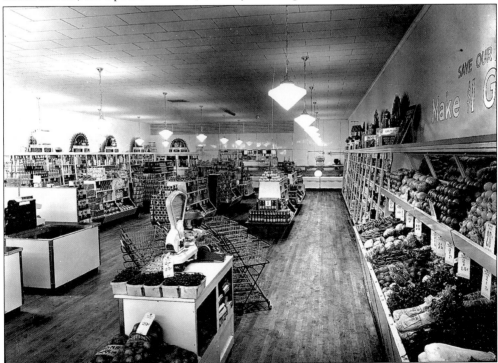

Neat and attractive, the interior of Nu-Way looks simple and old-fashioned, with its produce bins, scale, and miniature grocery carts. (Courtesy Hamburg Historical Society.)

Froehley's home, at 84 Lake Street, has changed a lot over the years, but it is still recognizable from this *c.* 1905 photograph. Hamburg's funeral directors had their own clientele: Froehley generally served the Protestants; Fogelsanger served the Catholics; Hess got the rest of the business. In the early years, Andrew Mammoser was a partner of Charles Froehley, then William C. and William L. Froehley. (Courtesy Jack Castle.)

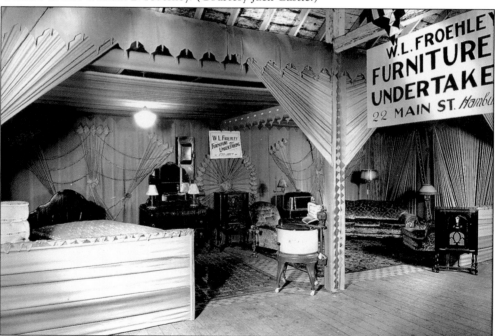

W.L. Froehley offered both furniture and mortician services, as did many furniture businesses of the time. In the early days, Froehley provided wooden furniture and wooden coffins. Froehley's display from the Erie County Fair shows the latest in floor radios, a waterfall bedroom set, and a wringer washing machine. (Courtesy Jack Castle.)

This cinder block home of Emma and William Haberer stood at 202 Buffalo Street, on the corner of Maple Avenue. The Haberers lived here with their children, Willie, Marcella, and Marita. William Haberer ran Hamburg's Dodge dealership one block away on the corner of Buffalo Street and Prospect Avenue. Eventually, the house was razed and replaced by a bank. (Courtesy Hamburg Historical Society.)

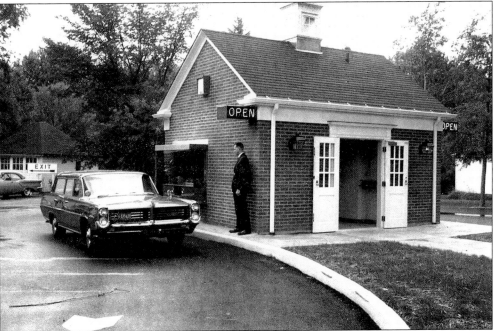

This drive-in branch of M & T Bank was opened on the corner of Buffalo Street and Maple Avenue in June 1966. Manager Stanley Youngman and tellers Barbara Walczyk and Dorothea Dietrich welcomed customers to their clean, efficient, modern facility. This small brick Colonial-style structure displaced the large cement block house (shown above) of William G. Haberer.

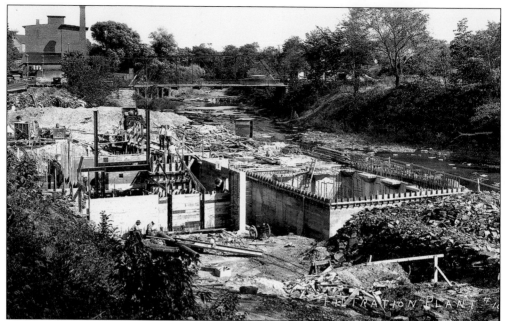

The construction of Hamburg village's filtration plant along Eighteen Mile Creek took place in the summer of 1927. A steam shovel was used for excavating, and considerable blasting was done to break up the shale rock bed. This facility took over the work of the Hamburg Water and Electric Light Company, on Prospect Avenue, as the population grew and the supply of well water dwindled. Drinking water was taken directly from Eighteen Mile Creek and purified before it was pumped to village homes. Shown are Schopeflin's Mill (upper left) and the old steel bridge linking South Buffalo Street with East Eden Road.

Sewage from the village of Hamburg entered this plant through an 18-inch pipeline. Two Imhoff tanks, one built in 1924 and one in 1952, removed solids from the sewage. Solids dropped from the upper compartment to the lower compartment, where it was digested for up to two months. Sludge was then pumped to the greenhouse, where it dried.

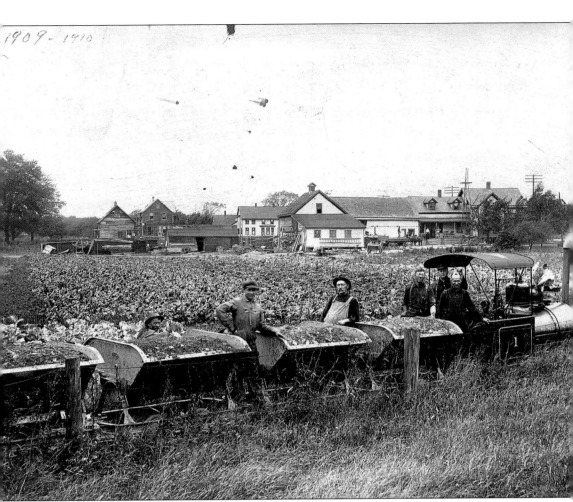

This little steam engine brought loads of stone and gravel to begin the paving of Buffalo Road, which connected Hamburg to the city of Buffalo back in 1909. Buffalo Road eventually was renamed South Park Avenue. Many Hamburg village streets originally had different names: Union Street was Parallel Street; Pleasant Avenue outside the village was Spring Street; Elizabeth was Park Place; Benderson was Harlow Avenue; Highland Avenue was once two separate streets—Elmwood from the trolley line west to Lake Street and Jennings Avenue on the east end near Buffalo Street; Parkside was William Street, but residents did not want it associated with William Street in Buffalo; the section of Center Street between Main Street and Long Avenue was Stuart Place.

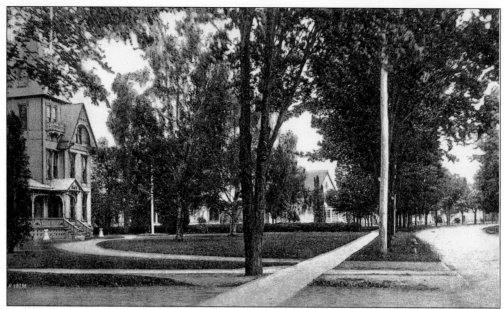

In 1910, the village of Hamburg was full of trees. On May 10, 1924, trees were used to honor the soldiers killed in the World War I by creating a "Road of Remembrance." Living trees were planted along a mile of Camp Road from the village line to Lake Shore Road. Hundreds of trees came from the state college of forestry. A huge parade was held, with the GAR veterans, the Women's Relief Corps, the American Legion, the Boy Scouts, and hundreds of men, women, and children. Woodlawn sent a large delegation because so many of the casualties were from there.

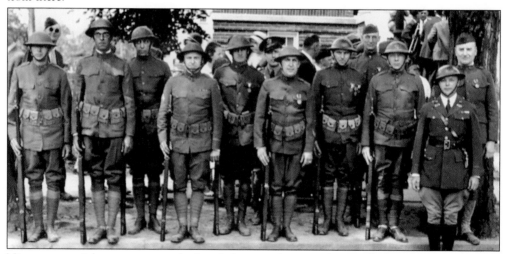

Nineteen special trees were marked with bronze plates, each inscribed with the name of a Hamburg soldier who died in the war. These individuals were Clifford Barber, Harry Clifton, George B. Conwell, W. Harry Davidson, Nathan Foote, Howard J. Gannon, William Groth, Howard Hodge, Frand LaPorte, Glen Maguet, Earl McDevitt, George O'Hern, Chester O'Neil, Edgar Salisbury, Martin Schaus, Herbert Shero, Alfred Stokes, Edward Wannenwetsch, and Lawrence Wolf. On May 10, 1924, the last tree was ceremoniously planted, the best bugler in the state played taps, and the Women's Relief Corps served a supper for the Gold Star Mothers. Shown are World War I veterans assembled in front of the Odd Fellows temple.

Five

FAVORITE HAMBURG PEOPLE

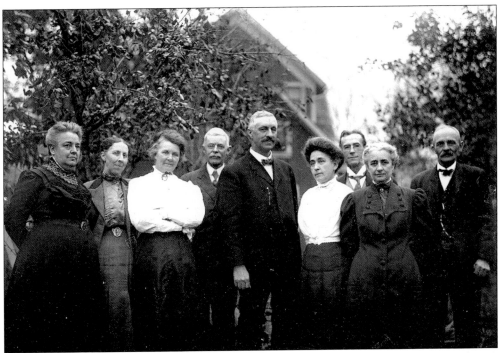

Hamburg relatives and their out-of-town guests gather for a photograph on November 6, 1910. From left to right are Katherine VanName, Mrs. Charles Dempster of Buffalo, Mrs. D.B. Littlefield, Newton Colvin, Mr. W.H. Jackson of Los Angeles, Mrs. L.I. Long of Denver, Junius Vanduzee, Helen Littlefield Colvin, and D.B. Littlefield. Katherine VanName and Helen Colvin were charter members of the Nineteenth Century Club, the group that founded the Hamburg Free Library. (Collection of Richard Laing.)

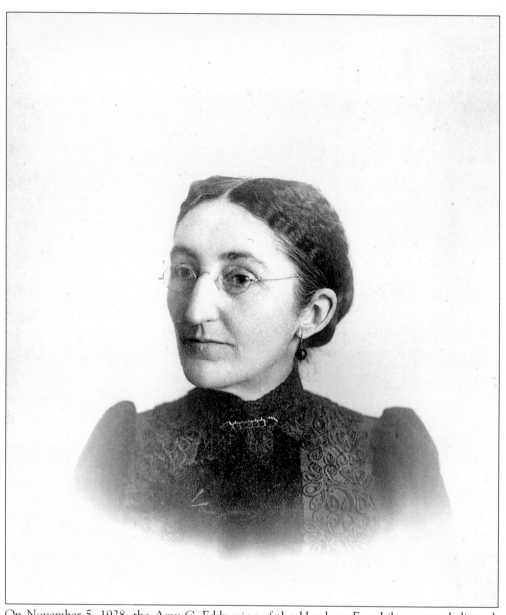

On November 5, 1928, the Amy C. Eddy wing of the Hamburg Free Library was dedicated. With her husband, George W. Eddy, Amy Cole Eddy ran various businesses along Lake Street, including a wallpaper store and the Lake and Eddy Store. When she died in 1918, she remembered the Hamburg Free Library in her will. After daughter and heir, Lillian Eddy, died in Los Angeles on February 15, 1928, a clause in Amy Eddy's will left $6,111 to the Hamburg Free Library. This money expanded the library's floor space by 75 percent, allowing for the construction of a reading room on the first floor and a storage room in the basement. (Courtesy Hamburg Historical Society.)

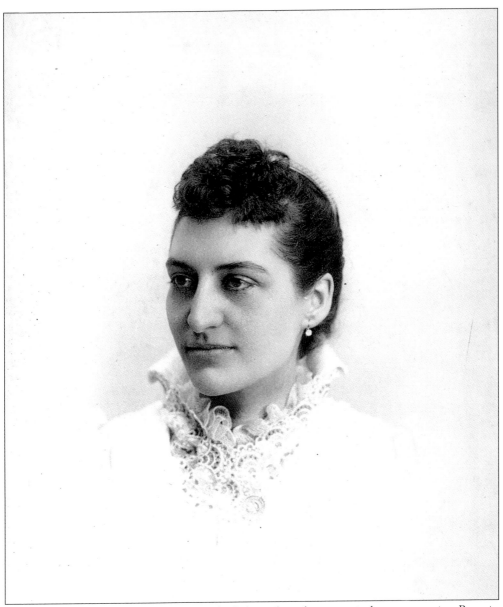

Lillian Eddy was special but also typical of the cultured women in her community. Born in Hamburg on October 2, 1865, she became involved in many different causes. She was a member of the Relief Corps, the Women's Christian Temperance Union, and the Society for the Prevention of Cruelty to Animals. She worked for 30 years as superintendent of the Cradle Roll, the Sunday school for young children of the Presbyterian church. She called the children in her Sunday school "rosebuds;" her signature is found on many certificates of merit. She was one of the original 19 charter members of Hamburg village's Nineteenth Century Club, which founded the Hamburg Free Library in 1897 and ran it on a volunteer basis until the New York State charter was granted in 1901. She and her friend Amanda Michael conducted many informative lectures for their fellow Nineteenth Century Club members on art, history, and literature. At her funeral there was a basket of rosebuds symbolizing all the children she had taught in Sunday school. (Courtesy Hamburg Historical Society.)

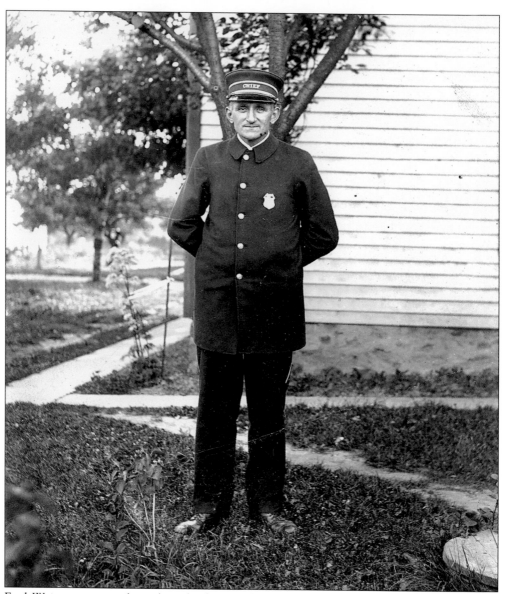

Fred Weiss was a popular police chief, remembered for his wisdom and kindness during his tenure. He was especially popular with young would-be troublemakers. When he found teenagers acting up, he took them to the police station and talked to them "like a Dutch uncle." The offenders would have to apologize, promise not to misbehave again, and mow the chief's lawn. After this, the teens were released and the trouble was forgotten. In July 1926, Weiss was unable to solve one village crime spree. It involved a mysterious woman known by several names: Mrs. Ribbons, Lillian Ellsworth, Mrs. Gibbs, and Mrs. Frisbie. The woman attracted attention by riding in her big blue Studebaker, driven by her "colored chauffeur," and by giving noisy parties on Union Street, which drew complaints from the neighbors. She then moved to the corner of Norwood and Lake Street, filled her house with new furniture purchased with bad checks, and finally left town. Weiss later learned that she had done the same thing in Albany, Ohio, Kentucky, and Pennsylvania and that detective agencies were after her when she fled Hamburg. (Courtesy Hamburg Historical Society.)

Members of the Weiss family relax outdoors. From left to right are the following: (front row) Harold "Tiny" Weiss and Grace Weiss; (middle row) Lizza Weiss and Fred Weiss; (back row) Roy Weiss and Mrs. Fred Weiss. Roy Weiss worked at the Hamburg Planing Mill for many years. Harold Weiss served as drum major for the Hamburg Volunteer Fire Department drum corps. As chief of police, Fred Weiss had a unique method of handling crime. On December 7, 1923, a couple of fellows in a Ford sped past him in a reckless manner. When he ordered them to stop, they stepped on the gas. So, Weiss hopped on the running board of an available car and told the driver, Clarence Milks, to follow the Ford. Weiss tried to shoot a holes in the Ford's tires but missed. The suspects jumped out of the Ford, which continued down the road without a driver. Milks had to swerve to avoid hitting the Ford, and in the process, Weiss was thrown to the ground and badly bruised. Weiss confiscated the Ford and held it, waiting for the owners to come back for it so that he could arrest them. (Courtesy Hamburg Historical Society.)

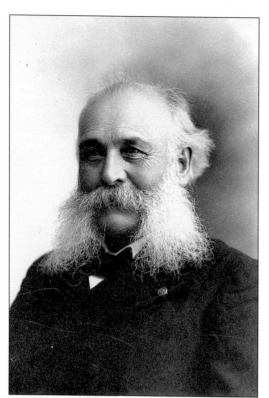

Dr. George Abbott was Hamburg's most famous early village doctor. Born in 1826, he graduated from Buffalo University medical school and served as principal of Hamburg School in 1852. He is remembered as a very good doctor who worked with cholera-epidemic patients in 1852 and with diphtheria patients in 1860. He served as a colonel during the Civil War, treating soldiers under primitive conditions. He joined the secret societies of Hamburg village, the GAR, the Odd Fellows, and the Masons. An avid supporter of temperance, he helped to organize the Hamburg Union School and Academy. When he was older, this man with flowing sideburns, moustache, and keen eyes served as school commissioner. He would appear at school programs, sit on the stage, rest his hands on his gold-headed cane, and pose questions to the terrified boys and girls. Abbott had two children, son George Burwell and daughter Eliza. (Courtesy Collection of Barbara Fox.)

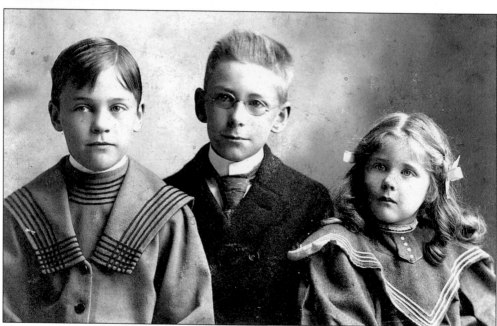

Photographed in May 1898, the three children of George Burwell Abbott and May McLaury, from left to right, are Burwell McLaury, age 9; George Francis Abbott, age 11; and Isabel, age 4. Burwell became a prominent store executive in Cleveland; George Francis became a famous playwright, and Isabel became Mrs. Hubert Juergens. (Courtesy Collection of Barbara Fox.)

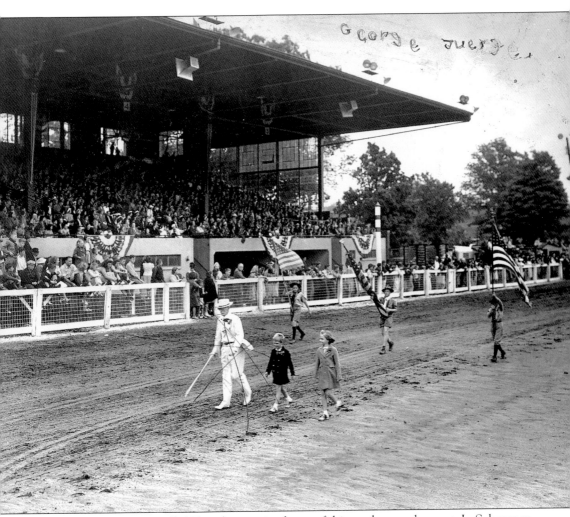

Somehow, George Burwell Abbott became in charge of things wherever he went. In Salamanca, he became mayor and organized the fastest fire department there, the Abbott Hose Company. Later, he moved to Cheyenne, Wyoming, where he worked as a land agent, settling claims and feuds—which sometimes ended in murder—between cattlemen and sheep ranchers. In 1902, he and his wife, May McLaury, and children returned to Hamburg. Soon, he was back in politics, serving as town supervisor and Erie County supervisor. During his terms, many bridges were built—big bridges, as he foresaw a huge growth in the number of automobiles. He also headed the Erie County Agricultural Society. This photograph shows him with his grandchildren George and Nancy leading the parade for Children's Day, August 19, 1940, at the Erie County Fair. When he died on February 4, 1942, at the age of 84, the newspaper described him as "straight as an arrow, slender as a youngster, always jauntily swinging a walking stick, he was unfailingly the perfect gentleman to his very finger tips." (Courtesy Collection of Barbara Fox.)

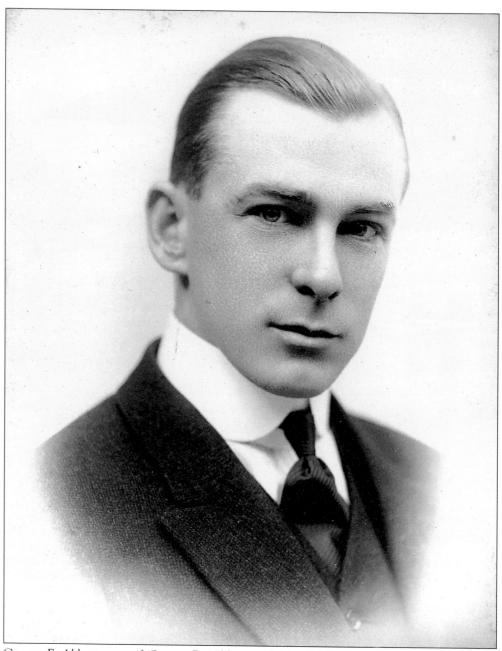

George F. Abbott, son of George B. Abbott and May McLaury, was a famous Broadway playwright and producer who lived to the age of 107. He graduated from Hamburg High School in 1907 and coauthored *Pal Joey*, *High Button Shoes*, and scores of other Broadway plays. He wrote his autobiography, *Mr. Abbott*, in 1963, detailing life back in Hamburg and life on the stage. He died in 1995.(Courtesy Collection of Barbara Fox.)

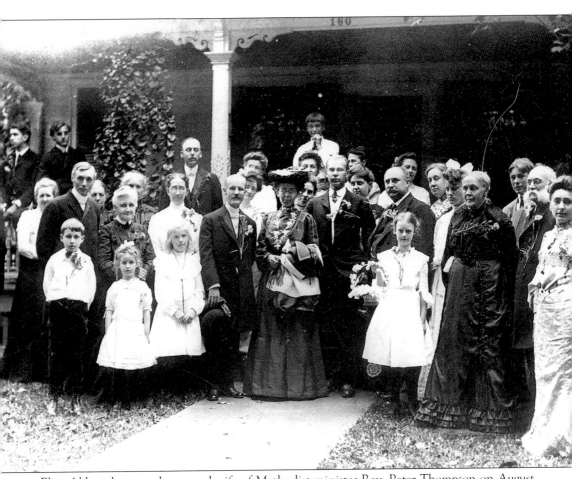

Eliza Abbott became the second wife of Methodist minister Rev. Peter Thompson on August 25, 1903, following the untimely death of Thompson's first wife, Margaret Grierson. Assembled at Thompson's home at 160 Union Street, the wedding party includes several of Hamburg's most interesting people. Among them are the Thompsons (center); the bride's brother George Burwell Abbott (near the pillar); George F. Abbott (third from the right); and grandfather Dr. George Abbott (second from the right). The girl with the basket of flowers is Thompson's daughter, Dorothy, who later became a world-famous newspaper columnist. A drama had occurred between her and Isabel Abbott (next to Thompson), the bride's niece. Dorothy Thompson. Eliza Abbott had always promised Isabel a certain piece of jewelry, but on this wedding day, she gave it to her new stepdaughter, Dorothy, instead. Much has been said against Eliza Abbott Thompson, but in her defense, it must be remembered that she was a member of the Nineteenth Century Club and a founder of the Hamburg Free Library. (Courtesy Collection of Barbara Fox.)

Smith Fenton Colvin was a well-connected Hamburg businessman whose early death left a void in the community. The only child of Lorinda Colvin, he was the husband of Ella Eckhardt and the father of George Willis Colvin. A cashier at the Peoples Bank for 12 years, he was popular and respected due to his uniform courtesy, kind interest, integrity, and good advice. He served as president of Hamburg village from 1904 to 1907 and was a member of the Hamburg School Board and of the Co-Operative Savings and Loan Association. He was treasurer of the Reuther Potato Digger Company and a member of the Business Men's Association (he was nominated for their first president, but declined), the Masonic Lodge, the Odd Fellows, and the exempt firemen. In the midst of an extremely active public life, Colvin died on August 22, 1915.

Ella Eckhardt Colvin, widow of Smith Colvin, organized a huge funeral, which began at the Colvin residence on Stuart Place (now Center Street) and required 14 flower bearers to carry floral arrangements. Masonic and Odd Fellow brothers marched from their temples to the Colvin home and then escorted the procession to Prospect Lawn Cemetery. Two ministers from the Lake Street Presbyterian Church officiated, and Joseph R. Smith, worshipful master, led the Masonic ceremonies. Born on February 5, 1882, Ella Colvin worked as village clerk for close to a decade and at the Hamburg High School cafeteria (where the students affectionately called her Aunt Ella) for more than 20 years. Her sister Florence Eckhardt served as principal of Hamburg Junior High and Hamburg Elementary Schools. Ella Colvin died on April 6, 1976. (Courtesy Hamburg Historical Society.)

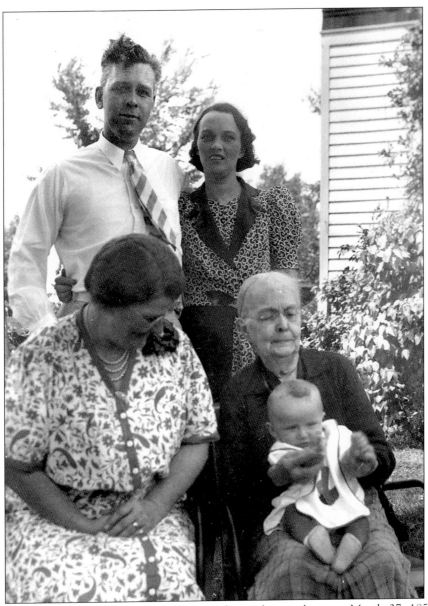

The woman holding the baby is Lorinda A. Colvin, who was born on March 27, 1854, and died on November 17, 1842. She was the daughter of John B. Salisbury and Sarah Eliza Pierce, the wife of Willis J. Colvin, and the mother of Smith Colvin. She was a leading member of the Nineteenth Century Club, which started the Hamburg Free Library. She was a great writer, composing the poem "It Reminded Somebody" to celebrate Hamburg's centennial in 1912 and authoring histories of the Hamburg Free Library and a long recollection of life in old Hamburg. Everyone called her Aunt Rindy and she made her home at 45 South Lake Street. When she died, the *Erie County Independent* said, "She was a living force in the community which she saw grow from the cross-roads called White's Corners to the present suburban community of nearly 6,000." Pictured with her, from left to right, are the following: (front row) Ella K. Colvin and Skip Colvin; (back row) George W. "Bud" Colvin and his wife, Mary E. Kelly Colvin. (Courtesy Collection of Skip Colvin.)

Amanda Michael, Hamburg's first librarian, was born in 1866 in Orchard Park, where her father, Henry Michael, ran a general store. In 1872, the Michaels moved to Hamburg village, relocating their store on the corner of Union and Lake Streets. Amanda Michael and 18 other Hamburg village women founded the Nineteenth Century Club, eventually opening the Hamburg Free Library in 1897. She started her career as a librarian on December 17, 1901, earning $10 per month. By 1922, she was earning $50 a month. In 1922, at the age of 56, she married Buffalo businessman Joseph Dorland and retired from the library (succeeded by Elizabeth Seelbach). She continued to actively support the library, to which she she donated the 1866 Ithaca calendar clock. She and her husband lived in the spacious and well-furnished home at 204 Union Street until she died in April 1934; her husband died six weeks later. She is buried in Prospect Lawn Cemetery; however, the Michael Cemetery, established in 1874 on Michael Road, is located in Orchard Park. (Courtesy Richard Laing.)

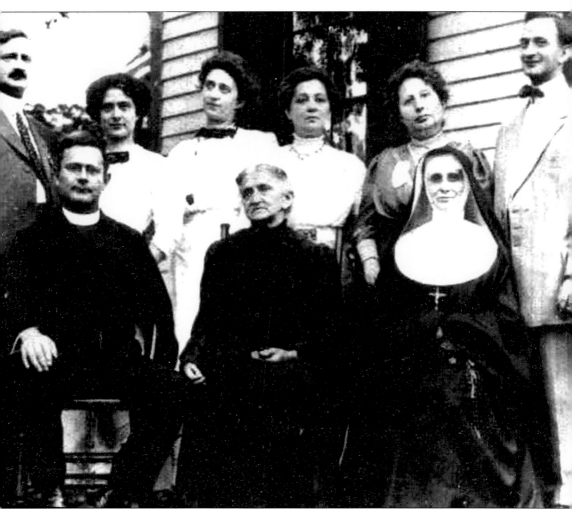

Hotel and tavern owner John Kloepfer (1833–1908) was born in Baden, Germany. He first married Hedwiga Schwanz (1833–1864), and after her death, he married her sister Rose Schwanz (1846–1927.) He fathered 13 children over a period of 25 years—Hedwiga had five children; Rose had eight. Shown at the family home, at 103 Buffalo Street, c. 1915 is Rose Kloepfer (front center) with her children; from left to right, they are as follows: (front row) William (Rev. Vincent, 1871–1925) and Mary (Sister Wilhelmina, 1862–1933); (back row) John A. Kloepfer (1873–1927), Cecelia (1883–1951), Emma Haberer (1876–1932), Anna Schwert (1864–1933), Caroline Stuart (1867–1929), and George (1875–1952). John A. Kloepfer worked as a cashier at the Bank of Hamburgh and, later, became president of Liberty Bank of Buffalo. He was one of the first trustees of the Hamburg Free Library when it was formed in 1901. When he died in 1927, he left an estate valued at over $600,000. His brother George served as bank vice president. The Kloepfer children donated two stained-glass windows in Sts. Peter and Paul Church in memory of their parents, John and Rose; the windows depict St. John the Evangelist and St. Rose of Lima.

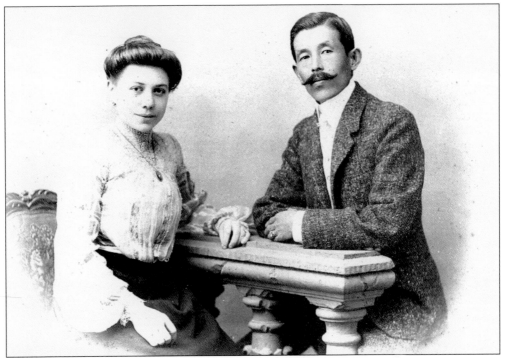

Hamburg was not noted for any ethnic diversity, but one Japanese-American family settled here and became quite famous. Yosaky Kudara came to Buffalo to conduct Japanese shows at the Pan-American Exposition in 1901. He married Buffalo native Irene Pabst and they had three children—Esther, Florence, and George Kudara.

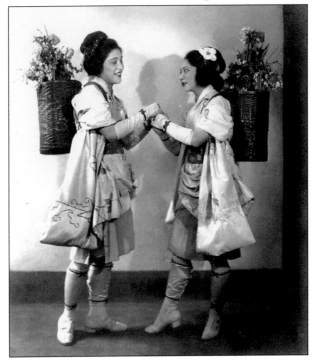

The Kudara girls went to New York City for dancing lessons and made their debut with Ed Wynn in the *Perfect Fool* in 1919. By 1936, the Kudara sisters were running a professional school of dancing in the Theil Building, offering lessons in tap, acrobatic, and social dancing.

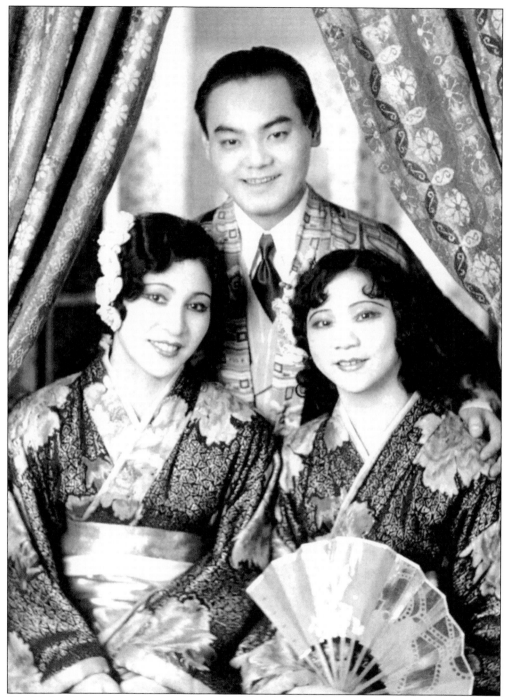

The Kudaras' stage name was the Three Meyakos, and in 1925, the family purchased a 92-acre farm on Taylor Road. A tenant tended the farm while the Kudaras were performing all over the United States and Canada. Later, the farm was known as Kudara's Grove and it was used for country picnics. From left to right are Esther, George, and Florence Kudara.

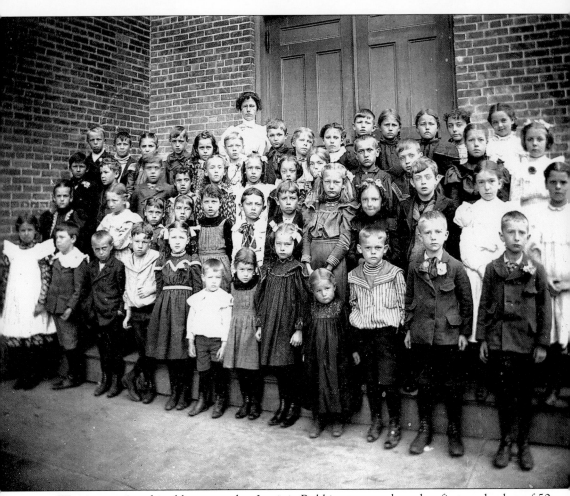

Wearing a crisp white blouse, teacher Lovinia Robbins towers above her first-grade class of 50 pupils c. 1910. She was an influential and beloved woman in Hamburg for decades. Her parents, Albert and Harriet Robbins, and the family lived next to the Hamburg Academy at 161 Union Street. She was one of the founders of the Hamburg Free Library and taught the early grades before she was appointed principal. When the library joined the Erie County Library System in June 1948, she was given library card No. 1. Many Hamburg school yearbooks mention her, saying that she was the first friend students made when they came to the Hamburg School. She died at the age of 91 on November 24, 1961, after teaching for 50 years. (Courtesy Hamburg Historical Society.)

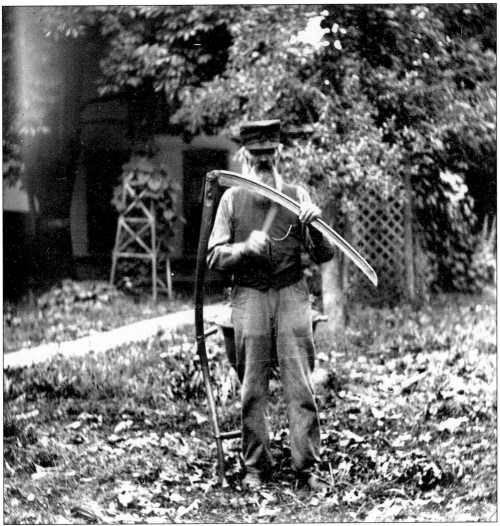

When Rudolph Stratemeier died on January 7, 1934, Hamburg lost the last of the old-time settlers who had arrived when White's Corners was little more than four corners at Main and Buffalo Streets. Born in Osnabrueck, Germany, on August 9, 1842, Stratemeier came to the United States in 1868. He married Catherine Schafer, who died; he then married Maud Ritter. Stratemeier lived at the corner of Main and Center Streets and worked as a cabinetmaker and blacksmith; he shod many teams of oxen. He was active in St. James Church as president of the church and as a Sunday school teacher. His son Henry Stratemeier served as Hamburg's mayor from 1931 to 1935. (Courtesy Hamburg Town Historian.)

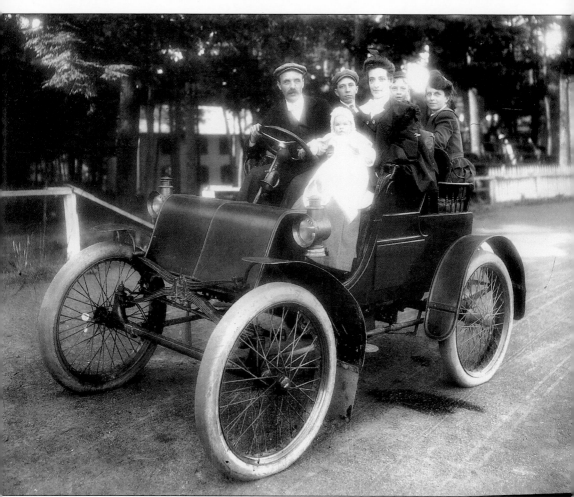

Everett Tooley took many of the early photographs of the Erie County Fair and the racetrack. This c. 1905 photograph shows him driving his wife, Gertrude Richardson Tooley, and their daughter, Evelyn, who became Mrs. Horace Hunt. The back-seat passengers, from left to right, are George, Graham, and Kate Harper. Gertrude Tooley's father, Lee Richardson, ran Richardson Milling in its early years. Her talented photographer husband died in Seattle, Washington, on May 20, 1907. (Courtesy Hamburg Historical Society.)

Six

CHURCH AND SCHOOL

East Main Street was a thriving section of Hamburg village, with Fink's Hotel across the street from Sts. Peter and Paul Church. This photograph shows the parish house that was moved from East Main Street to Pine Street and the second church, built in 1863, before the present brick church was built in 1912. (Courtesy Hamburg Historical Society.)

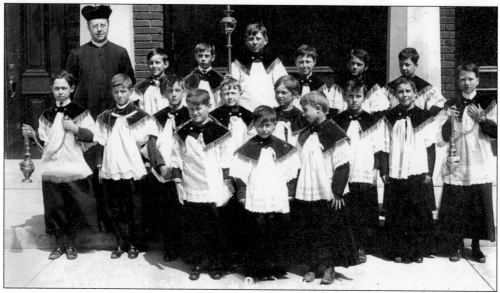

In the days before the Second Vatican Council, Catholic altar servers worked as acolytes, assisting the priest at Mass and answering the priest with Latin responses. These altar boys of 1913 are wearing Roman-style floor-length cassocks under white surplices. From left to right are the following: (front row) Art Demmerley, unidentified, and Aloy Moritz; (middle row) Werner Rose, Oddo Moritz, Art Espensheid, three unidentified boys, and Floyd Palmer; (back row) Rev. Anthony Bornefeld, unidentified, L. Fothum, Ed Reimer, and three unidentified boys.

Only boys served by the altar in 1969, when this group portrait was taken of Sts. Peter and Paul altar boys. From left to right are the following: (first row) Jesse Nuncio, Edward Mino, Carlton Foster Jr., Kurt Nicaise, and James Haefner; (second row) Michael Schaefer, David Yofiene, Rick Pfohl, Francis Ball, Kevin Friedman, and Thomas Young; (third row) Michael Kreamer, Michael Bobseine, James Yoviene, David Scholttman, Bill Nye, John Feldman, and George Forney; (fourth row) Daniel Kaszubowski, Thomas Daley, Robert Ryan, and Joseph Schwagler.

The first-grade class of Sts. Peter and Paul School poses for a picture *c.* 1910. Children in the class are Germain Branard, Christina Lautz, Evelyn Peters, Eileen Stuart, Viola Demerly, Leah Haberer, May Swan, Clara Lutz, Regina Schiedel, Clara Schiedel, Josephine Smith, Marceline Lederman, Herman Feldman, Philip Dustin, Edward Schuster, Leo Schaus, John Hill, Arthur Demerly, Clemens Mammoser, Glenn Doughty, Raymond Sauer, Aloysius Lederman, William Haberer, Howard McFadden, Floyd Ryder, Robert Ueblacker, Gilbert Palmer, and Willie John. (Courtesy Hamburg Historical Society.)

Sts. Peter and Paul Catholic Church established a school for its children in 1868. The first two teachers were Jacob Rie and Simon Schivert, with the sisters of St. Francis arriving to teach in 1874. The new Sts. Peter and Paul School was dedicated on September 3, 1922, with a ceremony conducted by Rt. Rev. Msgr. Nelson H. Baker, vicar general of the Diocese of Buffalo. Architects Bley and Lyman designed the school. Although not entirely complete at the dedication, the building had enough classrooms ready for the first day of school in 1922. The church started a high school in 1890 but discontinued it in 1933.

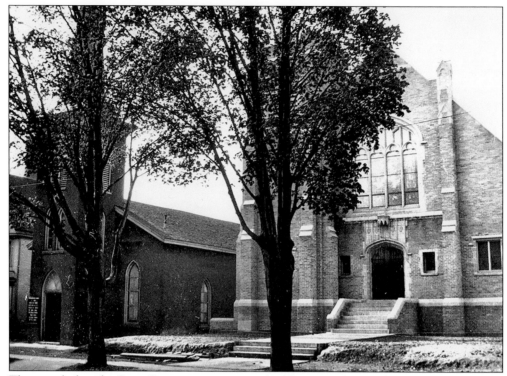

The years before the Great Depression were great building years for Hamburg. After outgrowing its wooden building on Main Street, St. James Evangelical Lutheran Church purchased the adjacent lot to the west from William C. Meyer for $10,000. Ground was broken on April 27, 1924. The pastor, Rev. A.E. Viehe, laid the cornerstone at 2:00 p.m. on July 20. A total of 12 pastors served from 1853, when the church was organized, until the new building was constructed. Architects Bley and Lyman designed the Gothic church, built of rough variegated cream brick trimmed with cast stone. The building measured 48 feet across and 108 feet in length. It could seat 400 worshipers on the main floor and 75 in the balcony. The old church, with its steeple, was taken down, and the old parish hall was moved to Legion Field to be used as the American Legion's clubhouse. (Courtesy Hamburg Historical Society.)

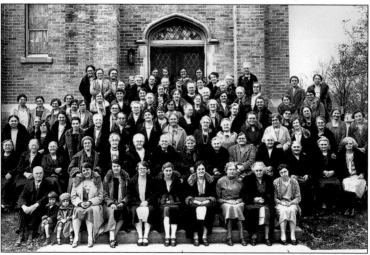

Members of the Women's Society of St. James Evangelical Lutheran Church pose in front of their beautiful new church in November 1928. This church has an old cemetery, now off Veit Road, next to Sts. Peter and Paul Cemetery. (Courtesy Hamburg Historical Society.)

It must have seemed like "divine intervention" when the Rev. F.H. Divine of Brooklyn raised over $100,000 in one week of March 1926 to build the new Methodist Episcopal Church. Rev. Earl D. Shepard conducted the final services in the old church on Union Street on August 28, 1927, before the 1884 wooden building was demolished to make room for the present brick structure. That day, Rev. Burton Clark mentioned some of the early Hamburg pioneers who worshiped at the church. They included Silas Wheelock, who joined in January 1832, Moses Dart, Edwin and Sarah Hunt, John Potter, Albert Flint, and George Gebhardt. The choir was joined by Leslie Lake, who sang a solo hymn. Eight children were baptized that morning before the congregation went outside for a group photograph. (Courtesy Hamburg Historical Society.)

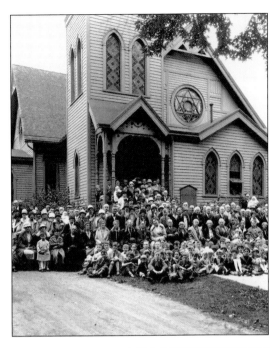

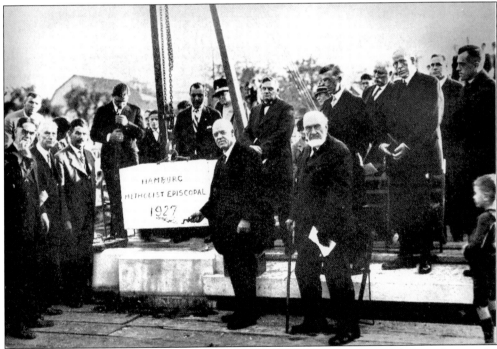

Dignitaries lay the cornerstone of the new Methodist church. From left to right are the following: (front row) Harrison Fitzgerald, George Bartlett, Charles Meyer (church builder), Rev. Earl Shepherd, Albert Flynt (the oldest member of the congregation), and Howard Mesnard; (back row, from center pole) Rev. C. Gall (former pastor), Reverend Leonard of the Presbyterian church, and Revs. Bertram Clark and Paul Hoffman of the Episcopal church. (Courtesy Hamburg United Methodist Church.)

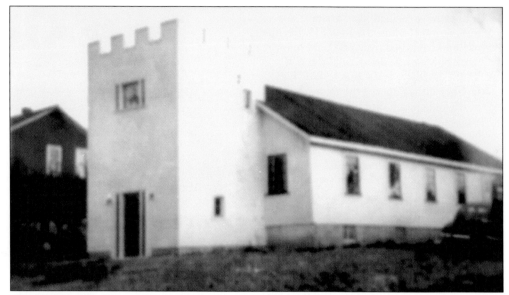

The Big Tree Wesleyan Church has been growing since Marietta Fancher started Bible classes and prayer meetings in homes and garages in Big Tree, Bayview, Scranton, Carnegie, and in the Big Tree Public School in 1932. A one-room chapel was built on Fairview Parkway in 1938, and it was called the Big Tree Bible School. Rev. Adrian Everts became the first pastor in 1946. The church has expanded and been remodeled many times, as the congregation has grown from a small band of devoted women to hundreds of families with an active missionary program.

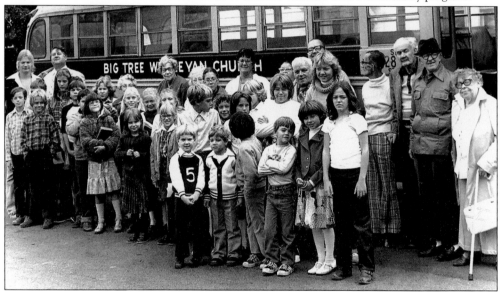

The Big Tree Wesleyan Church began its bus ministry in 1948 with a rented bus. Years later, the church purchased its own bus to bring children and people without automobiles to Sunday school and services. On cold mornings when this bus would not start, Rev. Edgar Lewellen towed it with his 1949 coupe until the motor turned over. Just as Marietta Fancher walked for miles to spread the word of her church, this church has sent its five buses to pick up anyone needing transportation to the place "where burdens are lifted." Among those pictured are bus driver Jack Strawbrich and bus captain Harold Blew.

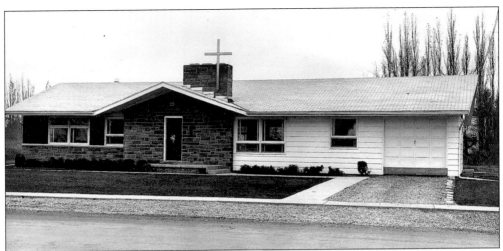

The Wesleyan Church has long been a vibrant part of Hamburg's religious heritage. A huge Wesleyan camp meeting, led by Reverend Fero, was held in August 1892 at the fairgrounds. Worshipers came from all areas of western New York; 600 people camped at the fairgrounds; 2,000 attended the Sunday service. By October 1892, the Wesleyan Church was meeting regularly in Hunt's Hall. The current Wesleyan Church of Hamburg began in 1957, when a group from Orchard Park set up a combination church and parsonage in this house on Sharon Avenue. In 1966, the congregation built a more substantial church on Newton Road. Eventually, the impressive complex on McKinley Parkway was built under the leadership of Rev. Greg McClain.

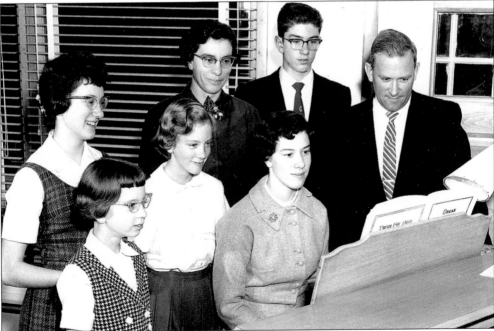

Rev. Roy M. Gibbs (right) served as pastor of the Wesleyan Church of Hamburg from 1959 to 1962. He left Hamburg for a church in Illinois, and Rev. Duane H. Janssen and Rev. H. Mark Abbott succeeded him. Pictured with him are his wife, Dora Gibbs, and their son and four daughters.

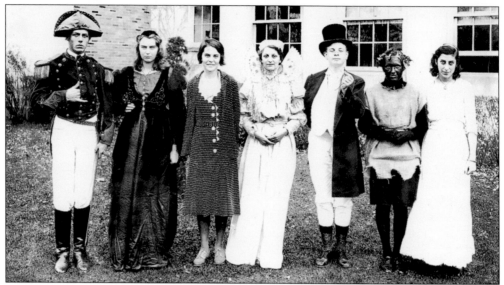

Hamburg High School librarian Pauline Munsey had students from her library club dress up as a character from their favorite book during National Book Week in November 1932. Gathered on the school lawn, from left to right, are Napoleon, Anne Boleyn, Agatha Christie, Queen Elizabeth, P.T. Barnum, Puck, and Juliet. Students with the best costumes presented a speech in the voice of their character at a school assembly held at the end of the week. (Courtesy Hamburg Historical Society.)

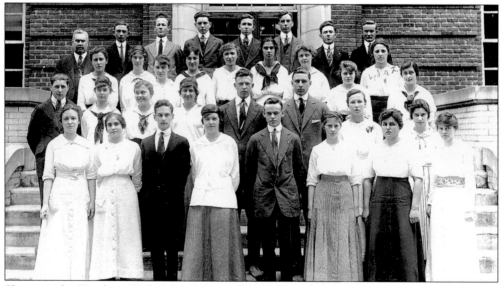

Shown is the Hamburg High School Class of 1916. From left to right are the following: (first row) Eunice Salisbury, Helen Fogelsanger, Heath Van Duzee, Celina Dodge, Warren Bourne, Martha Churchill, Laura Phillipi, and Laura Palmerton; (second row) Robert Eno, Celia Petrie, Louise Jones, Ruth Fagnan, Bentley Craig, Howard Baltzer, and Myra Critoph; (third row) Edna Potter, Leora Pierce, Esther Kleinfelder, Helen Huson, Esther Roeller, Teresa Hartkorn, Elsie Barnett, Mildred Riefler, Ivah McGee, and Lydia Zimmerman; (fourth row) Principal Arthur Downey, Leonard Arnold, Howard Sutter, Manuel Fleishman, Harold Wheelock, Milford Ebert, Joseph Palmerton, and Clarence Kuhn. (Courtesy Hamburg Historical Society.)

This huge study hall, located one floor beneath the school gym, held all four classes of the Hamburg Senior High School on March 29, 1915. (Courtesy Hamburg Town Historian.)

Girls' gym class at Hamburg High School involved games, dance, gymnastics, and some sort of ladylike exercise, in which everyone lay on the floor and raised their left arm. Teachers believed that proper physical conditioning helped student minds to function better and to more readily learn other subjects. (Courtesy Hamburg Historical Society.)

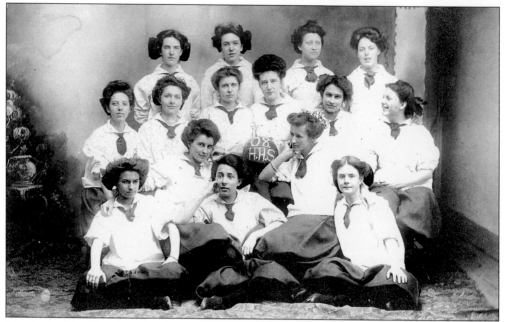

Members of the Hamburg Academy 1908 girls' championship basketball team are Ruth George McMillan, Jeanette Pellman, Esther Koelmel, Lillian Baltzer, Addie Andrez, Mabel Balthazer, Helen Stratemeier, Esther Herron, Lola Schaffer, Laura Hudson, Pauline Knight, Rosamond Hawthorne, Cornelia Fleckenstein, Ella Froehley, and Vivian Willard.

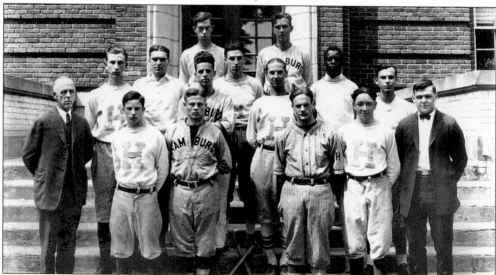

Pictured is the 1925 Hamburg High School baseball team. From left to right are the following: (first row) Principal Park, Emerson Learn, Leo Sterns, Harry Kerr, Bill McFarland, and Millard Pierce, manager; (second row) Clayton Bondelow, Mark Haberer, Harry Adams, and Everett Bennett; (third row) D.C. Pierce, Hook Leterman, and Sam Diggs; (fourth row) Clarence Coffey, pitcher, and Russell Draudt. Coffey was the team's star player, pitcher, and great sportsman. Until 1925, baseball games were not permitted on Sundays. The village ordinance was changed that year, allowing allow baseball to be be played from 2:00 to 7:00 p.m. on Sundays. (Courtesy Hamburg Town Historian.)

The annual train trip to Washington, D.C., was a tradition for Hamburg High School seniors during the 1920s and 1930s, and the trip was memorable for every student who went. In 1923, the seniors climbed the stairs to the top of the Washington Monument, visited the Lincoln Memorial, and went to Mount Vernon before visiting Philadelphia. Two students walked around an imposing column on a Washington street four times, looking for an inscription on it, but found that it was only an ornamental lamppost—quite unlike those back in Hamburg. (Courtesy Hamburg Historical Society.)

More than 5,000 people came from near and far to see priceless documents of American history when the New York State Freedom Train visited Hamburg for 12 hours on May 15, 1949. The crowd saw Abraham Lincoln's *Emancipation Proclamation* and original manuscripts by George Washington that were displayed in hermetically sealed display cases inside the train. (Courtesy Hamburg Historical Society.)

In its 75-year history, Wayside has had only two senior pastors. Dr. Walker Scott Brownlee (left) served from 1939 until Dr. David G. Persons succeeded him in 1976.

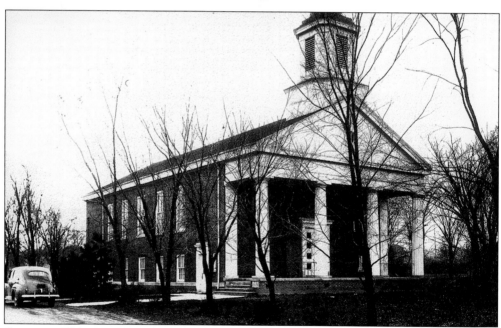

Passing its 75th year, Wayside United Presbyterian Church continues to be a strong presence on the Lake Shore. In January 1928, 14 people met in the old Wanakah School to plan the Wayside Community Chapel. Edith Roberts offered a large lot on Lakeshore Road and her husband, John T. Roberts, donated $500 to start the project. The Roberts family lived with two servants on Summer Street in Buffalo, and Mr. Roberts ran a candy company. During the Depression years, churchwomen ran weekly bake sales. In 1938, the chapel joined the United Presbyterian denomination.

Seven

BLASDELL, BIG TREE, ATHOL SPRINGS, STEELTON, LAKE SHORE, AND LAKEVIEW

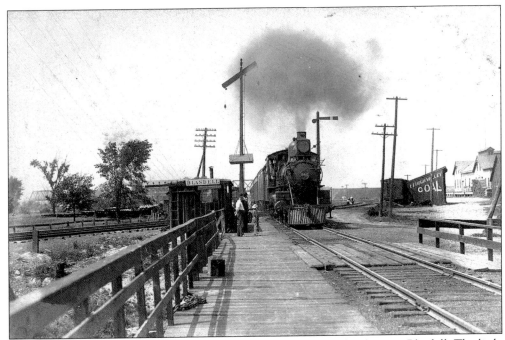

This postcard, by Isaac Kingsland, shows the original train stop that became Blasdell. The little shanty with the Blasdell sign was a train car removed from its wheels. Heman Blasdell took the initiative naming the tiny community with his own last name. This postcard is considered the Holy Grail of Blasdell cards.

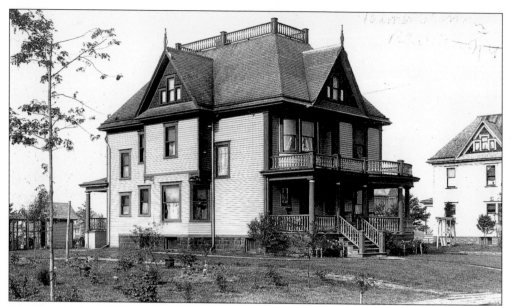

The Skinner family came to Blasdell because of their sons' love of fishing. The sons of the elder Palmer Skinner persuaded their father to trade land in the town of Boston for land in Blasdell, which was closer to the water for fishing. This home on Helen Avenue was built for the younger Palmer Skinner and his wife, Maria Knapp. The house had a veranda, fancy spindle railings, a large reception hall, and a beautiful open stairway. The Skinners hosted an annual coon bake for the entire community and annual dinners for alumni of Blasdell High School.

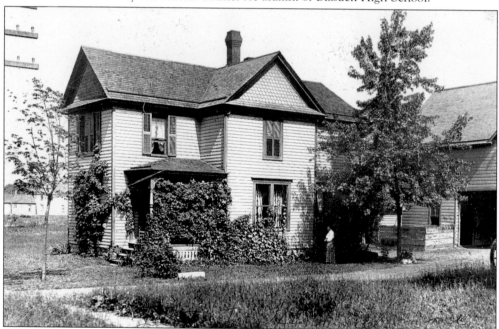

Three major Salisbury families appear in early Blasdell history. Oliver Cromwell Salisbury lived in this home. He served as president of the village of Blasdell from 1900 to 1902. He was the son of John and Susan Price Salisbury, who lived in the old Salisbury Inn in Woodlawn. (Courtesy Hamburg Town Historian.)

This postcard shows Lake Avenue c. 1905, with its unpaved street and some wooden sidewalks. At this time, land developer W.A. Fargo of Buffalo issued a leaflet selling lots in what he called the Orchard. Fargo described the Blasdell community in the following way: "Blasdell has about 70 houses, three factories and a new electric power house, two railway, two telegraph and two express stations, post office, three large and two small stores, hardware store and tin shop, blacksmith shop, harness, wagon, carpenter, paint and shoe shops, new $5,500 school-house, brand new town hall, two churches, a resident physician, four hotels, butcher shop, etc, etc, with a population of 400." Inexpensive building lots were offered for $75, with weekly payments of $1; costlier lots were available for $225 or $1.50 per week.

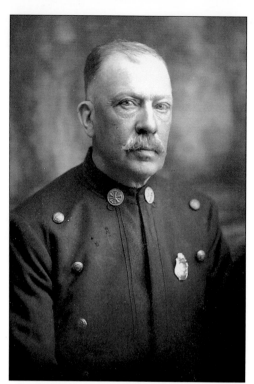

James W. Stutts was born in July 1863. He ran a grocery store and then a plumbing and stove shop on Lake Avenue. He was the first president of the village of Blasdell from 1898 to 1899, before the office was changed to mayor. Later, from 1919 to 1920, he served as Blasdell fire chief. (Courtesy Carlin Collection.)

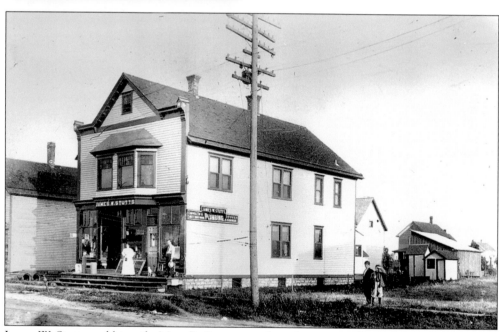

James W. Stutts and his wife, Mary R. Stutts, stand on the steps in front of their Lake Avenue plumbing supply store. Mary Stutts holds her purse, which was the cash register of the business. All the money went into her purse, and she made change out of it. Her husband may have been president of the village of Blasdell, as well as its fire chief, but she was the boss. (Courtesy Carlin Collection.)

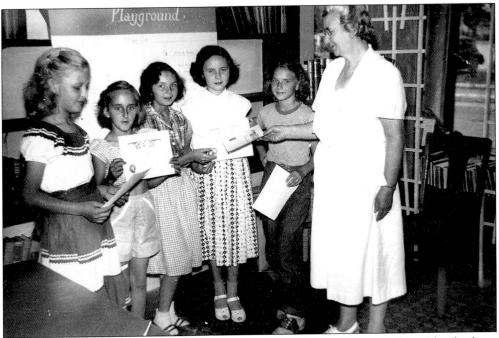

Librarian Ethel Thompson (right) presents certificates of participation to five girls who have completed one of her summer reading programs in the Blasdell Free Library building at 90 Lake Avenue c. 1946. The old library was set up in three different buildings on Lake Avenue. The library received its provisional charter in 1937, when it was located in the rear of the Bank of Blasdell building, on the corner of Lake and Labelle Avenues.

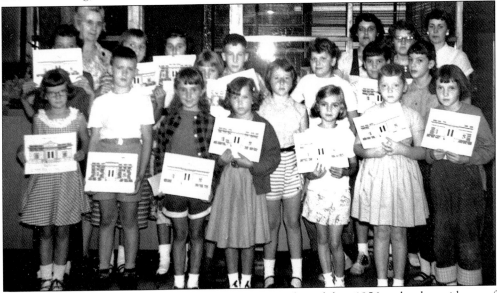

Boys and girls attend the Blasdell Library's summer reading club c. 1956 under the guidance of librarian Ethel Thompson (back left). The children followed the theme "Let's Build a Library." For each book they read that summer, they pasted a small picture of a book on to their larger picture of the library. Two years earlier, in 1954, Blasdell adults had built the real library, on the corner of Madison and Salisbury Avenues.

This railroad bridge can be seen in the background of many early Blasdell photographs. It still stands today. Originally called the Depew and Lake Shore Terminal Bridge, it was built near the old Excelon plant, west of Electric Avenue. The bridge went over the Lehigh Valley and Nickel Plate company tracks between Blasdell and Lackawanna. (Courtesy Carlin Collection.)

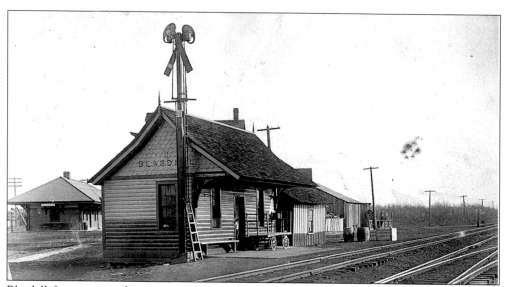

Blasdell first grew in the vicinity of the railroad crossing on Lake Avenue. This photograph shows two early Blasdell stations: the Erie Depot (left) and the Pennsylvania Depot. (Courtesy Carlin Collection.)

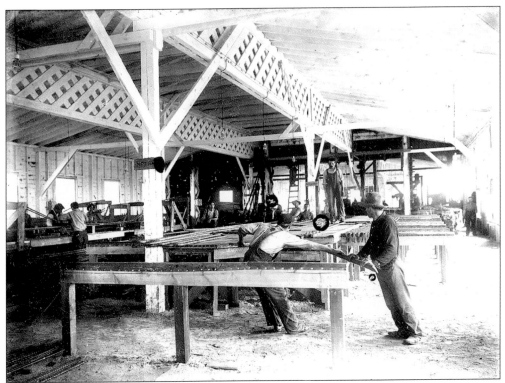

This early photograph shows the interior of the old Seneca Mills in Blasdell. The workmen in front are bending steel rebar by hand to a customer's specifications. (Courtesy Carlin Collection.)

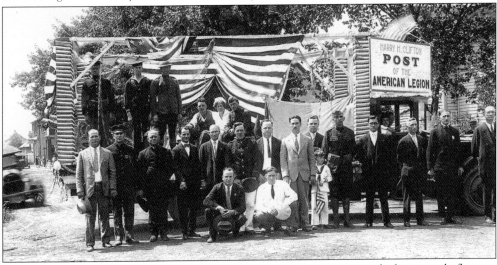

Members of the Harry H. Clifton Post of the American Legion pose with their parade float on Labelle Avenue on August 6, 1927. From left to right are the following: (front row) Frank Oaks and John Fritz; (middle row) Jake Zuppinger, John McKenzie, Joseph Pfohl, Ray Grinder, Tim Mullholland, Grant Colley, Ed Foose, George Davidson, Jack Graham, young mascot Eddie Zuppinger, John Thompson, Doc Palmer, John McKenzie, Jim Meyers (1st commander), and George Peters; (back row) William Tucker, Walter Bailey, William Funk, unidentified, Mrs. Grant Colley, William O'Connor, and Jim Baker (in the cab). (Courtesy Carlin Collection.)

Three Blasdell Elementary School students, Robert Sealy, Beverly Bianco, and Patricia Girdlestone, display the pole they have made from a coat rack to gauge the donations they have collected for the war effort, aiming for a total of $208 for the Wartime Savings Stamps program. For every donation of 25¢, a student got a stamp to paste in a folder. When the folder was filled, it could be redeemed for a U.S. war bond. Throughout town, the American Legion ran the Smokes for Soldiers campaign, collecting money to buy cigarettes for servicemen. (Courtesy Hamburg Town Historian.)

In 1942, five Blasdell fourth-graders show their patriotic spirit by posing with an Uncle Sam figure they made from stovepipes. From left to right are Fay Collard, Robert Salisbury, Rose Stevanoff Danforth, Edward Smith, and Stanley Zak. Uncle Sam had a hole in the top of his hat so that people could donate small items such as keys for the World War II scrap metal drive. Throughout town, mother had to hide her kettles and father had to hold on to his rakes and lawn mowers to keep the children from donating them to the scrap drives. Blasdell enclosed the lot on the corner of Salisbury and Madison Avenues with a storm fence. (Courtesy Hamburg Town Historian.)

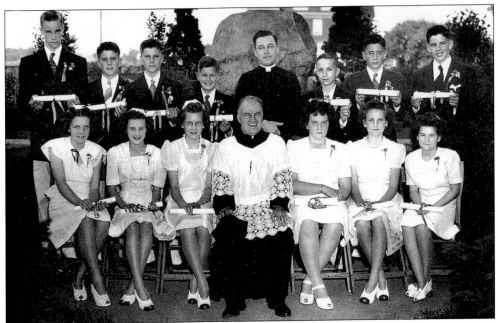

Diplomas were presented to the 13 teenagers from Our Mother of Good Counsel School's eighth-grade class in June 1946. From left to right are the following: (front row) Margaret Carlin, Mary Brogan, Mary Lou McNally, Rev. Leo J. Toomey, Maryann Willis, Rosemary Rayburg, and Shirley Blair; (back row) Richard Kohn, Richard Suto, August Dylik, Rev. Duggan, Anthony Krzesinski, Robert Keefe, and Joseph Bager. The school colors were blue and gold, and the graduates wore blue and white bachelor's buttons. Father Toomey, a colorful priest who was nicknamed "the bishop of the lakeshore," sometimes led his congregations in a special prayer for the success of Notre Dame teams before important games.

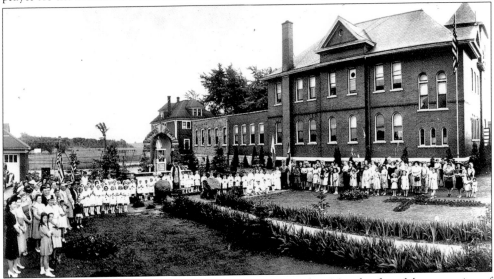

Parishioners of Our Mother of Good Counsel gather on a fine May day for a May crowning of a statue of the Blessed Mother. Father Toomey led the procession to the grotto behind the old church-school building. Men from the parish constructed an addition to the school building, using bricks they salvaged from another demolished building. (Courtesy Carlin Collection.)

Three well-known Highland Acres residents—Sixtus Roorda, Marie Albrecht, and Charles Albrecht—wait for the trolley for a trip to Niagara Falls in 1918. Roorda was a native of Argentina; Charles Albrecht ran the Albrecht Brothers Gasoline Station, a local institution. Marie Albrecht later became Mrs. Sixtus Roorda. (Courtesy Hamburg Town Historian.)

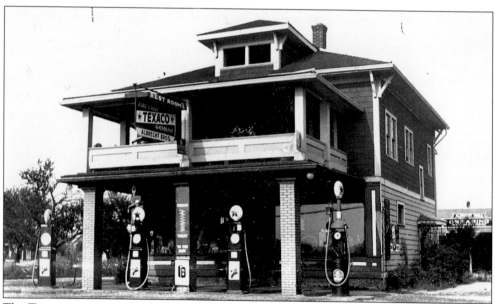

The Texaco station run by the Albrecht brothers stood at the top of "the hill," at 4215 South Park Avenue in Highland Acres. Mary Albrecht came from Germany in 1887 and lived here with her children, Charles, John, Joseph, and Janet. Charles and John Albrecht ran a small penny store inside, and the station became a gathering spot for discussions of all types. Parade judges sat on the second-floor porch to review the many fire department parades that passed along South Park Avenue. Charles's wife, Stella Albrecht, a great cook, made the fish fries that were served across the road at J.J.'s Tavern.

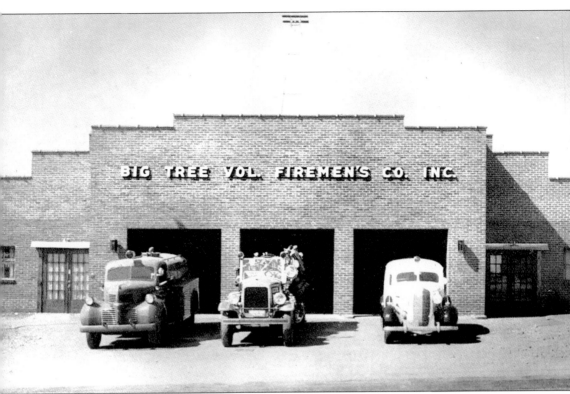

The Big Tree Fire Company comprised those men who happened to be in the vicinity when a fire broke out. They kept a hand hose cart, buckets, and fire hats and coats in Fred Wulf's barn and distributed the equipment to the first men who came to a fire. In 1936, three different groups of men were meeting at Albrecht Brothers Gas Station, Schoen's Grille, and Joseph Kryzak's Garage to talk about starting a fire company for Highland Acres and Big Tree. The first fire department building was located on Highland Parkway. Every year after Christmas, neighbors would bring their discarded Christmas trees and the firemen would build a huge bonfire. On November 2, 1936, William Koenig was elected chairman of the fire company and men from the community were asked to join. A chemical truck was purchased, and Joseph Kryszak was appointed as the first fire chief. The ladies auxiliary was formed, and the first of many field days was held. For parades, the marching unit wore green-and-tan uniforms. In 1948, the fire department moved to its present location, on South Park Avenue, between the McNaughton estate and Syl Barbati's garage. This garage had three bays for the trucks; a coatroom, bar, and kitchen on the left; a bowling alley on the right; and a large hall in the rear. The siren atop the fire hall gave loud blasts whenever firemen were needed. (Courtesy Hamburg Town Historian.)

The Athol Springs station stood south of the powerhouse, where Camp Road, formerly called Gowanda Road, crossed the railroad lines. At that time, Camp Road ended at the Fresh Air Mission, on Lake Shore Road, and above the shore of Lake Erie. The homes of H. Helderhouse, F. Saunders, and W.E. Wakely bordered the Athol Springs station. This postcard, dated 1914, shows numerous power lines along the tracks.

Utility lines bring civilization to the community of Athol Springs, as they branch off from the railroad line. The Buffalo and Lake Erie Railroad passenger car was used as a little waiting room in Athol Springs c. 1910. Why construct a building when a passenger car could provide a place to sit protected from the Lake Erie weather? In a similar way, Blasdell used a railroad boxcar for its first station. (Courtesy Collection of Nancy Rhoades.)

The Athol Springs powerhouse stood at the juncture of the Buffalo and Lake Erie Railroad line and the Lake Shore and Michigan Southern and the New York Central and St. Louis railroad lines.

The dramatic cliffs of the Athol Springs rise up above the shores of Lake Erie at the site of the YWCA vacation home. Many wild storms have visited this shoreline. In 1951, a 50-foot jetty was built on the north end of the Hamburg town beach to preserve the beach sand and prevent erosion from the winter storms.

The Heiser family owned this house when it stood on the lake's shore, before Bethlehem Steel bought property along Lake Erie. The Heisers had it moved to its present location, on Allen Street in Big Tree, or Steelton, and the Landsittel family purchased it c. 1915. Shown are the Landsittels, from left to right, Viola, Loretta, Helen, George, Edward, and John. The family dog's name was Tojo. (Courtesy Collection of Eric Lindstrom.)

Land in Big Tree was relatively inexpensive when it was settled, and many families bought several building lots there. The Allen trolley line connected residents with the city, but the neighborhood still had a bit of country flavor to it—in this case, the flavor of chicken. John Landsittel enjoyed life as a gentleman farmer, cultivating a few acres and raising chickens. (Courtesy Collection of Eric Lindstrom.)

The community of Steelton, located off Big Tree Road, has been a quiet neighborhood, with people who have stayed there for generations. This c. 1927 photograph shows, from left to right, Donald Landsittel, his sister Elinor Landsittel Lindstrom, and their cousin Ellison Thornton. Houses with additions and outbuildings line Bristol Road in the distance. (Courtesy Collection of Eric Lindstrom.)

This house on West Avenue in the "new" section of Steelton is typical of many working-class cottages that were expanded over time here and in Hamburg's beach communities. First a cottage, it was moved on its lot, then expanded front and back, covered in asphalt brick-pattern siding, and then expanded again. (Courtesy Sylvia Levier.)

Park Hotel and Cabins was located on Lake Erie on Lake Shore Road in Wanakah. Charlie Rosenaur came here from Germany in 1910, and his family settled on the lake shore in 1938. The "big house" was bordered by little white cabins, which were rented daily or weekly by vacationers from April 15 until Halloween each year. The cabins rented for $5 a night or $25 per week and were numbered from 1 to 16. There was no cabin 13—no one wanted to take a chance with the weather while on vacation.

In the 1940s, the cabins shown above were combined, showers were added, and the roof was extended to create Rosenaur's Park Motel. Charlie Rosenaur, his wife, and daughters, Doris and Bev, operated the motel, and Marie Cleveland of Cloverbank worked as their longtime waitress. The same families vacationed here year after year. and in the evening the women would watch the orange sunsets while enjoying Horton's coffee and pie and the men would gather for man talk and a glass of beer. Nearby, visitors could stay at Truskiel's Trailer Park, Mrs. Treed's Tea Room, or Kellner's Grocery Store, which employed orphans from Father Baker's Home in Lackawanna. In case of trouble in the neighborhood, the state police were down the road in the town park.

As early as 1880, wealthy lawyers from Buffalo were spending their summers along the shores of Lake Erie in Hamburg. The original 55 members of the Idlewood Association could each purchase one acre of desirable property in Evans and Hamburg at the mouth of Eighteen Mile Creek. Hamburg was just a short train ride from Buffalo, and impressive summer homes were built in Idlewood for many Buffalo businessmen. Influential businessmen had a train station built for Idlewood, even though it was just a short distance from Lakeview. This residence, called Cedar Hurst, stood in Lakeview. It features Tudor style and a porte-cochere, a covered carriage entrance.

This postcard, sent from Lake View in 1909, shows the circular driveway and gardens of Cedar Hurst. The driveway suggests the active social life of this resort community. Although quite a number of impressive summer residences were built after 1900, many of them, such as this one, have vanished. When fortunes were lost during the Great Depression, summer homes were abandoned. Many of the homes were lost in fires, as the bridge to Idlewood could not support the weight of a fire engine until recently. The Idlewood Association went bankrupt, and in 1945, Mr. Irish of the Erie County Savings Bank purchased the property.

When a new railroad line was planned, a new bridge was needed next to the huge viaduct across Eighteen Mile Creek in Lakeview. Since the creek was quite a distance below the railroad tracks, this double bridge was constructed with steel trestles to hold the railroad tracks above—even though the entire area was filled in with a huge amount of earth. (Courtesy Collection of Gary Pericak.)

The wooden forms made to construct the Eighteen Mile Creek Bridge in July 1942 dwarf workmen and their truck on the worksite. Earlier, one of the forms had collapsed, causing construction delays. The bridge opened in 1943. (Courtesy Collection of Gary Pericak.)

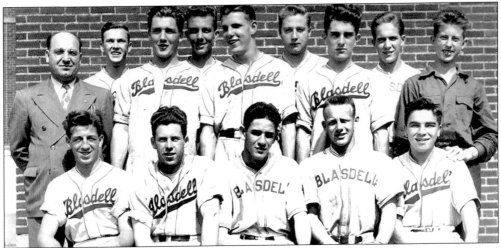

The 1945 Blasdell High School baseball team poses for a picture. From left to right are the following: (front row) Stan Prusak, Dan Patterson, Roger Kendell, Dan Rucker, and Boris Stavreft; (back row) Mr. Gullo, Tommy Hileman, Joe Jordah, Stan Stoklosa, Chuck Barlett, Joe Yaccobucci, Russ Texter, Herbie Gardner, and Bill Funk. As an 18-year-old senior, pitcher Hileman threw a no-hit, no-run game against Woodlawn's team. (Courtesy Hamburg Historical Society.)

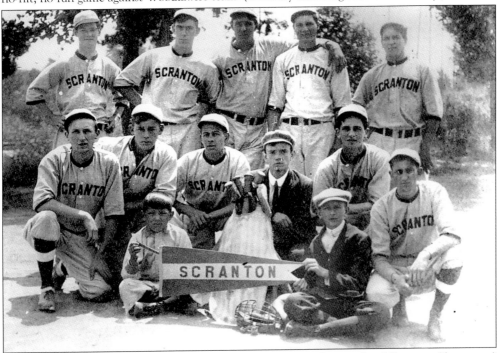

Pictured is Scranton's 1911 baseball team. From left to right are the following: (front row) mascots Raymond Feldman and Hugh O'Neill; (middle row) Clifford Hall, Freddy Briggs, Irving Sprague, Red Berry, Horace Palmer, and Valentine Bockover; (back row) George Robinson, Timothy Baker, Tony Mauser, Alton Peters, and Dave Trutt. Scranton was first called New Scranton because men came from Scranton, Pennsylvania, to work in the steel plants here. Building lots were priced low, and many of the streets were named after famous presidents, including Lincoln, Washington, and Garfield. (Courtesy Hamburg Town Historian.)

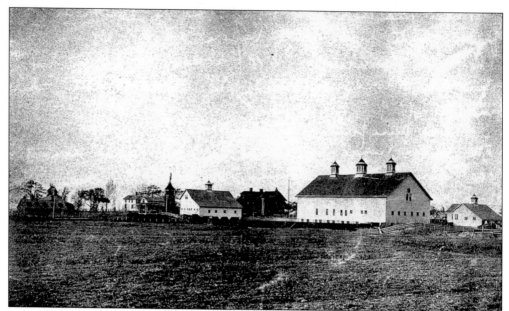

The 416-acre farm of Truman G. Avery stretched from Locksley Park nearly to Cloverbank Road. This pre-1901 photograph was owned by Walter E. Knapp, who lived on the farm from 1901 to 1911. Unfortunately, fires destroyed the farmhouse and large barn. (Courtesy Hamburg Historical Society.)

These three houses were built for hired men working on the Truman G. Avery farm on the Lakeshore. They stood on the corner of Rogers and Lakeshore Roads, near a road that ran down to the Lake Erie Railroad branch. (Courtesy Hamburg Historical Society.)

This view of Amsdell Fork, on the Ridge Road, shows the pavement suitable for horse-drawn carriages and automobiles. The road inspectors found it had no ruts and no soft spots at this intersection. Amsdell Road preserves the name of Abner Amsdell, who settled on the lake shore in 1805 with his wife and four children. Amsdell was a veteran of the Revolutionary War and fought in Shays' Rebellion before moving west and following an old Indian trail from Buffalo to what is now Wanakah. His son Abner Amsdell II, who died on December 11, 1888, at the age of 94, remembered following paths through the woods from Wanakah to the village of Hamburg to attend a crude school in the pines on the future location of the B.M. Fish Store. Robert Amsdell, a brother, went on to expand the family farm. Today's community of Amsdell Heights is located on that land. A historic marker was erected in 1971 to mark the location of the early stagecoach stop and the ancestral home of Abner Amsdell. (Courtesy Hamburg Historical Society.)

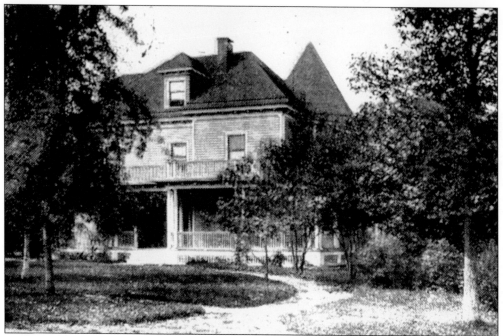

Lovely, spacious homes, such as Hillcrest of Wanakah, graced the Lake Shore Road *c.* 1910. (Courtesy Jack Castle.)

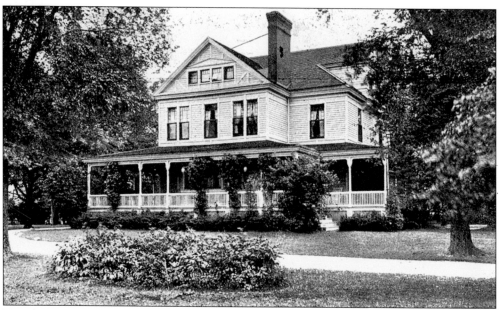

Noted soap manufacturer John D. Larkin bought property in Idlewood in 1882 but lost his daughter in a fire accident in 1885. The Larkin Country Club, three or four buildings in Athol Springs, was used as a country club for Larkin employees. An article in *Ourselves*, the Larkin Company newsletter, described this country club. (Courtesy Jack Castle.)